CHALLENGES
AND
DISCOVERIES

INSPIRATION AND ADVICE FROM
THE JOURNALS OF AN ARTIST

To Claire
Be creative!

VIC RIESAU

DEDICATION

This book is dedicated to my family, especially my loving wife Beverly, who has always been essential to my success in every sense of the word. And to my two sons Brad and Todd, all of whom give me great inspiration and support and without whom this book would never have been published.

ACKNOWLEDGEMENTS

I gratefully acknowledge the following individuals for their generous support in the development of this book. To John Geragthy, Special Advisor and Trustee of the Autry National Center and Western Heritage Museum for your foreward and long-time friendship. To Peter Adams, artist and President of the California Art Club; Maryvonne Leshe, Managing Partner of the Trailside Galleries, Scottsdale, AZ and Jackson, WY; Eric B. Rhoads, Publisher of *Fine Art Connoisseur, Plein Air* and *Art Advocate* magazines; and Richard Schmid, pre-eminent artist, author and educator – thank you all for your kind words of support and encouragement.

Special thanks to sons Brad for his hours of expert editing, literary and promotional guidance and Todd for

initial proof-reading and who for 30 years has worked diligently by my side in the studio.

Heartfelt thanks to Dr. Joel Heger without whom I would not be here to enjoy this experience. To Robert R. Hepler who provided a wonderful cover concept design. To my long-time art students Dan Kingston and Dennis Kuntz who along with Joel and Robert provided weekly encouragement for this book.

FOREWARD

‣ ⊰⊱ ‣

I first met Vic and Beverly Riesau when establishing the Masters of the American West exhibition and sale fifteen years ago at the Autry National Center in Los Angeles, California. Vic was president of the A.I.C.A., a group of professional artists that had held their annual exhibition at the Autry Museum.

As a nationally recognized, dedicated and enthusiastic artist, Vic's assistance in initiating the Masters was invaluable.

Although an established sculptor highly respected among his peers, with numerous monumental works to his credit, he continued to challenge himself creatively. I found his diversification compelling. It was obvious as a true artist, he was attempting to reach for the limits of his potential.

Vic had mastered the understanding of form, perspective, composition and design. I was not surprised when he approached me in 2007 requesting a hiatus from this prestigious exhibition. He had become increasingly interested in painting. Although he continues to accept commissions for monumental sculptures, he was compelled to return to the easel, again to reach out and challenge himself. I continued to watch his work with great interest. His drawing ability had been acquired during his years of design. I found his adaptability amazing.

He eagerly examined the masters and mentors, which brought him confidence, skill and individuality that provided access to the creative mind and pictorial thought process of a master artist.

I can't think of anyone more qualified to write and publish these observations and gems of insight from a lifetime of artistic inspiration and creativity than Vic Riesau.

John Geraghty
Special Advisor and Trustee
Autry National Center and Western Heritage Museum
Los Angeles, California

TABLE OF CONTENTS

INTRODUCTION

T he purpose of this book is to bring to the attention of aspiring artists, as well as to those painters who have already begun a career in the arts, important aspects in the life of an artist rarely taught or written about. These observations pertain to the many *Challenges and Discoveries* confronting them in their careers. Much has been written about and demonstrated on how to paint but I intend here to discuss how to prepare for and sustain a life as a fine art painter.

The book is the result of excerpts from my journals and written at the suggestion of my students over the years. It is organized for easy access to any subject without having to search or read ahead. Readers can open any page and hopefully find some worthy advice or inspiration.

Very little has been published on the personal, professional and business challenges an artist must deal with in the course of their careers. It has been my observation that only too often, budding fine artists, having not been adequately prepared or having neglected the pending necessities beyond development of technical skills, have altered the course of their careers in the fine arts. The result of the loss of many talented painters is detrimental to the future and continued resurgence of Traditional Realist painting.

I hope this little book helps. Read it, learn and enjoy.

Vic Riesau

OVERTURE

B eing an artist is about challenges and discoveries. It is about failures and successes and about suffering and pleasure. The pleasure is in the process. Acknowledge that and enjoy it. Satisfaction if ever, really comes in the process, rarely in the finished work. It is worthy if others enjoy it and your ego is served.

Recognizing the challenges and accepting them is the important beginning. An artist should not stay or work in his comfort zone of challenges previously met. Be bold, if something strikes you, go for it. Vitality can soon disappear and the flame of imagination and passion instead of fueling the fire dwindles.

Recognition of why you emotionally want to paint and the decision of what you choose to paint are as important as how you paint.

Let's not kid ourselves, we don't paint for others, we paint for ourselves. However, always be cognizant of others' opinions, good or bad. In either case it is easy for ego to get in the way of self-assessment. Many have become known and financially successful because they have learned they can paint a certain subject well. Such a scenario prompts some dealers to influence artists to paint more of the same because they sell. This scenario can be a career hindrance for the artist. Never confuse sales with artistic success. Learn as much as you can about Impressionism, Expressionism, Traditional Realism and Modernism. Decide which you prefer and delve into it in knowledge and practice.

Study failures, yours and others'. The art world is full of them. Always be self-critical. A difficult challenge, particularly in today's busy world, is the development of strong work habits. In them, you will discover a fulfilling joy.

Look for the best teachers available and realize the best artists don't always make the best instructors. Filter out non-essential and time-wasting efforts. Select teachers and projects that honestly challenge your abili-

ties. Only then can you learn. Read selected books, journals and articles by knowledgeable and intellectual writers.

There are two levels of observation you should practice. First, visit and study good exhibitions and the work of other artists. Secondly, you should constantly observe the world around you during your waking hours. Observe the changing light of the day, shadow patterns and compositional potentials.

Drawing is both the beginning challenge of a painting career and one that will stay with you until the very end. The quality of your tools and materials is another challenge that has a definite effect on the quality and development of your work. Buy the best that you can afford.

It is a long journey from the eye to the mind and that journey is manifested in the creative work of artists. Along the way from conception to completion, every step taken presents a challenge. In reality, that challenge begins when one decides to become an artist. The inspirations prompting such decisions are undoubtedly many. There have been hundreds if not thousands of books

written on *how* to paint but relatively few on *how to be a painter*.

What I have tried to do in these pages is focus on the *CHALLENGES AND DISCOVERIES* necessary to experience in the journey to become a painter. Every mental and physical step along the way involves both.

It matters not what the goals of an aspiring painter are, be they grand or simple. Any degree of desired achievement requires challenges and discoveries along the way. But be forewarned, the challenges and processes are like love, just a little is not enough. As the saying goes, nothing succeeds like success and there is no success without a prepared mind.

WHAT IS TRADITIONAL REALISM

True art in traditional realism is in the painting of a scene or subject that generates, on canvas, visual images representing the honest emotions of the artist in response to his experience. They can be as simple as a single flower or as complicated as the Grand Canyon. The painting is successful if the same emotion is spontaneously perceived by the viewers.

An emotional response always precedes analysis. Your passion for the subject will be reflected if you maintain the observation and inspiration that originally attracted you. This represents a common spirituality present in all people although some have a greater sensitivity to beauty from a spiritual standpoint than others.

Paint the subjects you really want to and those that strike a magic chord within you. Don't paint to meet popular demands or trends. A good painting will always stand out if it is well done and well presented.

Strict painting, i.e. copying from photographs, can nearly always be detected, as the camera distorts images. What looks like an excellent photo realistic painting is surely a superbly done work by an extremely competent artist.

You must choose your style and develop it. Don't fish around for some magic. All styles require dedicated work.

In any traditional realism painting, regardless of subject, the principles remain the same. If the subject is portrait, figurative, still life, landscape or seascape the

precepts enable you to more easily accomplish the subjective content you strive for.

Although your paintings are not technically illustrations, the subjective content (as opposed to objective forms) may well tell an emotional or spiritual story.

As an example, the artist's intent in painting a winter scene is not to elicit the reaction, "Oh, look at the snow." Rather, the artist's intent may have been to get the emotional response, "That sure looks cold."

The evolutionary and physical marvels of the natural world, from the simplest stone to the human figure, are so complex we are still striving to understand them. Yet, the aesthetic beauty of all things natural in their unique form, give us great pleasure.

These images in nature have stirred the imagination of artists throughout history.

Why is there greater and more universal pleasure in things natural than in things manufactured? Pleasure derived from the latter stems from admiration for things we have created ourselves. The difference is strikingly obvious in the purpose, motivation, and influence of

what the traditional realist artists strive for and the ideals and works of the modernists.

The desire and satisfaction derived by the former is evident in the replication of the beauty of what has been created in nature for us. It must indeed have a genesis, understood or not. Why else is a forest more touching to the soul than things fabricated? This fact gives the representational artist an important responsibility, that of reminding us of who we are, from whence we came, and of our role in the grand scheme of things.

I suspect that the vast majority of representational artists rarely, if ever, think in such terms but rather seek satisfaction solely in capturing the beauty perceived. Deeper reflection into the subconscious spirituality will give greater purpose to your work.

The irony to all this is that perfection is impossible and except for very few artists, the quest for a masterpiece is doomed to failure. Regardless, what a wonderful and glorious trip you, the artist will have.

ART AND NATURE

The universal element throughout the history of traditional art has been the connection to life in all its varied and wondrous forms. The recent publicity regarding the cave drawings in France makes us aware of the conscious artistic interpretive mind of even prehistoric man. The quality of the drawings and the depiction of herding and animal anatomy made 32,000 years ago are truly astounding. They are evidence of earliest man's spiritual connection with nature and of his desire to document this relationship. That connection has endured throughout the history of realist art.

The natural world has always been prevalent in the arts and we are experiencing a resurgence of interest as we know more about it. Nearly all civilizations have depicted the basic life source, the sun, as a simple but vital form that somehow provides light, warmth, and growth throughout the natural world.

Is it any wonder we are drawn to its gifts as artists or that it is the undeniable source of beauty that we seek to portray? We are blessed to recognize nature in our unique way.

There are inexplicable ties between the perfections of the natural world and the artist's passionate drive for depicting that perfection. An artist's lot is the impossible task of literally bringing sunlight onto flowers, rocks and water and to breathe life into mere images. They must create the illusions of emotions, time, space, movement and the elements where none exists.

Those goals are inherently impossible, so what drives the representational artist in his journey to failure? It is man's spiritual bond with the miracles of life in the natural world. It is a desire to touch the senses as only a visual artist can.

There is an intimacy with nature that is missed when looking at a *distant* vista regardless of its beauty. Shorten your field of vision and you will experience sights, sounds and wonders otherwise missed.

A walk in the woods, along the seashore or mountain stream will provide endless challenges and potential for your creativity. Better yet, these more intimate views of nature will bring to mind memorable experiences and provide a refreshing view of nature in your work. These

intimate views become a new and interesting challenge. Thus there are limitless subject choices.

More importantly, these choices can be beautiful and express a spiritual connection with the natural world.

Remember your purpose is not merely to capture the objective forms of nature but the subjective elements within your painting that are the source of your inspiration.

Learning to observe and remember are traits that will come easily as your interest in painting progresses. If you cannot paint it as you see it, enjoy the challenge and paint it as you feel it. Quick sketches and notes are an invaluable aid. Remember, those moments of magic are one-time events.

LANGUAGE OF THE HUMAN SPIRIT

Art is an important cerebral key to our emotions and human nature. The attraction to a painting rests solely on the visual content shown within its borders. The "language" of the painting, i.e. the way in which the meaning is expressed, must be created as an extension of

the human spirit. The content should express that spirit, nourish it and enrich it.

This spiritual "language" is the living force of all successful traditional art and the "communicators" are the artist's secret tools of visual expression: composition, form, color and light. These elements enable us to convey what we have experienced with our senses and translated via our imagination and intelligence.

The judicious use of these elements, as in writing, is to keep things simple. An overly complex composition or too intense color can overwhelm your painting and lose the desired emotional impact.

In addition, the use of various types of lines can convey a variety of psychological meanings. A sharp, jagged line can convey tension or nervousness while a smooth, curving line can imply gentleness.

Color can provide illusions of hot, cold, light, darkness and a whole range of values that contribute to the truth, logic and emotional resonance of your painting.

REALISM vs. MODERNISM

Traditional realism, modernist art and post-modernists are born of different cultures and are not and should not be compared or considered as competitive from an aesthetic standpoint.

Historically, the modernist movement almost totally rejected the natural world and as a result alienated itself from traditional cultural art society. Thus there has developed a perceived elitism within the modernist enthusiasts prompted by the relative ease of painting for the market and the combination of entrepreneurs, collectors and ordinary buyers. The trend toward a great number of modernist works being appropriated by the clean, utilitarian design culture is evident.

With the more successfully promoted and talented artists came a celebrity status that further established them. With that celebrity status came quite often, emphasis on the artist rather than on the art itself.

Nonetheless, by its content and association with the natural world, understood universally by all, traditional art remains hugely popular among the masses.

Has traditional realism in the arts lost the battle? Is this perception a question of value or of numbers? There should be no conflict at all. Modern art and traditional art serve separate and distinct purposes. Modernism has the advantage of a more prevalent media presence, which is conceptually driven while traditional art appeals more to the instinctive and emotional connection with the natural world. This translates into two very distinct economic markets.

In regards to the appreciation of art as a whole, what has actually been lost in the technological rush to a homogenization of a culture that has all but forsaken the natural world?

The problems are indeed many, but the human spirit remains alive through realism in the arts. The myriad demands and distractions of modern life unleashed a consuming monster on traditional realism and nearly precluded the development of artists willing or able in today's culture to learn, much less, master traditional painting. In that culture since the 1940s, there was a near disappearance of classically trained teachers for aspiring artists. Many advanced art schools virtually eliminated

fine art from their curricula although we are seeing a recent reversal of that trend. Today's aspiring traditional artists are most often learning from a steadily increasing number of workshops or private instruction by advanced artists.

In the last decade, the resurgence of the interest in plein-air painting, the infusion of some masterful artists from other countries, and the proliferation of art clubs internationally has resulted in a regeneration of interest in traditional realism. As noted below, the vast majority of people painting today are traditional painters. Along with the satisfaction of creativity, I am certain there is an aroused interest among painters in the spiritual association with the natural world.

Examination of the celebrity factor in today's dominant art culture reveals two distinct subcultures, the artists and the collectors. Important to understanding is the actual perceived notion that the more hyped Modernist school is the more dominant one as opposed to the Traditional Realist. In fact, the general populace much prefers the latter as the vast majority live a very

traditional life and have an evident preference for art reflecting the natural world and human experience.

As I have written before, the culture for which the Modernist movement developed directly serves and parallels the advancements in the design of much of our daily lives. In that commercial, product-oriented culture there is an acknowledged need for enhancing shapes and color. This aids in the promotion of modern art to the corporate and business world.

We are seeing a dramatic increase in the number of highly recognized traditional artists accompanied by an increase in overall market share at all levels. This development has produced a significant number of celebrity artists painting in the traditional manner. The auction houses are reporting record prices for some of these traditional works.

CHALLENGES AND DISCOVERIES

T he challenges, frustrations and discoveries in becoming an artist are many and never ending. Perhaps the most enlightening and difficult is the often career long challenge and discovery of ultimately knowing oneself. Some may realize it sooner than others. It has to do with attaining a level of self-comfort and confidence in your chosen line of work. If you reach that plateau, the journey will be worth every minute of it.

The mere act of just being a part-time painter offers endless satisfaction in meeting challenges and making thousands of enlightening discoveries on the road to creativity.

However, the joy comes sooner and easier with being prepared for the tasks ahead.

There are a number of basic challenges once you have made your decision to be an artist, part or full-time. Many others will follow throughout your career, some major and thousands of minor but no less significant to the immediate work.

First of all, use your time wisely, form good work habits. Time spent in planning, study and experimenting is never wasted time. Well-learned technique and good ideas are good basis for action and your job is to bring visual order and interest to that action. Never start until you feel that excitement about what you're going to paint and then be particularly attentive to your beginnings, hold yourself back from trying to finish before you've even begun.

A good solid beginning will eliminate struggle as surely as a bad one will guarantee it. Remember, everything about your craft is based on fundamentals and expert use of them is the key to successful work. Fortunately, we can list them:

Good drawing

Good organization of shapes (composition/design)

Proportion (relative sizes)

Construction (form)

Each of these fundamentals can be the subject of infinite study. A good painting is always well structured.

The challenge of knowing why you paint or want to paint may not be evident at first. I expect that very few have the passion for it that they eventually will have if they stay with it and seriously study.

What it takes is to understand that you need not become a master or even an acknowledged artist to realize why you paint.

As a representational artist, particularly a landscape artist, you will soon discover a relationship with nature you had always subconsciously possessed. For purposes here we will leave the painting advice on how to paint to the myriad of art books and available workshops.

For this discussion, the "how to paint" is answered simply — paint emotionally but with discipline and purpose.

Respond to the truths of nature, the magic of light, color, shadow, wind, snow, etc. As to what you paint, the

answer is anything! Be conscious of the subjective elements as opposed to the objective forms. Your paintings are not about objects, they are not about the eyes, they are about the mind. Instead of thinking about what you see, think about what you feel, your emotional response. Accomplish this by concentrating on painting the subjective elements rather than the form or objects.

The objects in a representational traditionalist painting are only the messengers used to communicate the drama and beauty to the mind of the viewer. Don't paint by rote. Paint with a purpose to communicate with the viewer. You must be prepared before you can effectively practice the physical techniques of doing that. You can't represent something meaningful unless you know WHAT you want to SAY by your efforts and how to communicate that in your paintings.

SPIRITUALITY

Are you aware, even conscious of the spiritual aspect of your work as a traditional representational artist? It is sometimes difficult without some concrete evidence or personal experience to make that connection. To dispel

any doubts, it sometimes takes a miracle to provide that inner assurance. Sometimes in our search for convincing evidence, we fail in our painting adventures to recognize the millions of miracles occurring all around us. Let me assure you that there are miracles virtually everywhere.

Take note that all the beauty we choose to depict was not created by some accidental phenomenon. Just look around and think about it.

Think about how the enormous complexity and inter-dependency of the natural world always beckons and provides for us the beauty of artistic inspiration. Imagine the truth in the miracle of reproduction of all species, plant and animal. Such amazing truth could only exist by divine creation. It could be no accident.

Extend your imagination to the wonders of color and light with which we deal on a daily basis and without which there would be no fine art painting.

Why do lions seek other lions to mate with and not leopards? Leopards are prettier. Why does an acorn become an oak and not a pine?

When you walk out the door into the natural world, realize that all the peoples on earth share in the same wonders.

THE TRADITIONAL ARTIST
AND SPIRITUALITY

The true success of the traditional artists is not measured by the products of our labor but by the understanding achieved through the unique expressions of our humanity.

There is a profound and direct relationship between a traditional realist artist and the natural world. This relationship has been expounded upon by many artists throughout history. However, it is decidedly absent in writings or comments from the contemporary modernist school. The modernist school is dedicated to work that augments and enhances the modern design culture and is not concerned with reflecting the spiritual elements of nature that traditional realism is prone to explore.

Traditional realism if done well can transcend the gap between the intent of the artist and the perception by the viewer. In experiencing, contemplating and painting

nature, the artist engages both himself and the viewer in an intimate dialog with the universal spirit.

The wonder of nature brings us in every minute a picture never seen before and which shall never be seen again. Recognize what you see that provokes an emotional response within you. It may be slight or stop you in your tracks. These experiences are the subjective truths in your paintings. They represent the drama and beauty in the scene, which for artists and viewers alike stems from the spiritual aspects of our individual personalities and shared humanity.

Our world, our existence, and the core foundations of all we experience evolve from the natural world in one form or another. THINK ABOUT IT!

So why were we turning away from traditional realism? What is real? What is sacred? Do we need recognition of representational realism to preserve our culture? Without the natural world that we choose to depict and which represents life in all forms, there would be no existence, only a void, a vacuum.

We, as representational artists, have an obligation to preserve an awareness of the miracles of the natural

world. Sharing our creative expression of nature's timeless inspiration, in a large part, defines the path we have chosen.

As a result of the Industrial Revolution, the advent of modern design has prompted decades of critical popularity for the modern school of art. These so-called "taste-makers" seem to have forsaken recognition of the greatest gift of all, nature, for the comforts, conveniences and pleasures of our modern culture. They are losing touch with reality and truth in its most evident form. There is nothing as absolute as truth. Fortunately, traditional realism, which has long been favored by the general population, is experiencing a resurgence critically.

Can the human spirit survive without verbal and visual reminders offered by the fine arts?

MOTIVATION

One of the greatest challenges for most artists is that of determining what their motivation is as an artist. In truth, a relatively few maintain the same motivations they began with. The necessities of life and the realization of the limited number of artists making a living with their

art are very common factors in budding artists having to change course of their objectives. It has been reported that one half of one percent make their living as full-time artists. This is one of the realities of the business.

As I have written, one of the other first realizations is that an artist will almost surely never paint the masterpiece he or she has hoped for. However, the primary motivation of most artists I know is create better and better paintings, perhaps even fine art.

The realities of ego or financial gain as motivation is not realistic except in some rare cases. But as any artist will gladly confess, the joy of painting is unmatched by few other endeavors.

As long as there have been written reviews or criticism of the artist's work, the volumes have very rarely examined or attempted to analyze the underlying psychological or spiritual aspect of their motivation. Such analysis nearly always comes after the artists have gone and then it usually pertains to a dominant theme in their output. Such comment may or may not be valid under the circumstances. Conjecture by others, as to why artists paint what they do, is just that, conjecture.

There have been occasional writings by artists themselves who were either aware of the need for such analysis, and were inclined and capable of written expression. From these there is much to learn.

Those writings can be important learning lessons and motivation for any aspiring artist. They can help you fine-tune your own awareness of what you do. Use their knowledge and experience as stepping stones in the discovery of your own motivation.

THE CHALLENGE OF PREPARATION

Although learning the technical principles and techniques of painting is essential, there can be no substitute for preparation and prerequisite knowledge of the business of being an artist. By "business" I am referring to everything BUT the painting. From the seemingly trivial details to the big picture issues, research and preparation of all of these aspects increase your readiness for the challenges and discoveries to come.

More important than learning how to paint is learning how to be a painter! There are very few better ways to learn than discovering your failures and correcting them.

Perhaps the greatest challenge during the development of your career as a fine art painter is the reality of the need for commitment and sacrifice.

The discovery of that need comes in degrees after the original bug that bites you turns into a lifetime of both tribulation and great joy. There never seems to be enough time.

There is the first challenge of deciding that an artist is what you want to be. Then comes the multiple challenges of learning your craft. It is during that extended period of time that a serious commitment and personal sacrifices become very real problems.

A fine artist works mostly in isolation so there are solutions to family, professional and social relationships that must be seriously considered and dealt with.

Step beyond your acquired knowledge and accept the challenges of preparation that will make your desired skills that much easier to develop.

Be realistic in the selection of your choices. Don't be afraid of challenges not met. Use what you learn to meet the next challenge head on.

Don't let your ego prompt you to constantly repeat your failures or for that matter your successes, less your efforts become trite. If you are critically honest you will recognize your failures, apply what you learn and move on, remembering not to repeat them. Practice the habit of seeing the artistic potentials in the world around you.

Observe, recognize and think about forms, composition opportunities and the phenomenon of perspective atmosphere and space. They constitute challenges as you work. Be a sponge! Suck up all the knowledge offered or demonstrated by others. You should be careful not to reject criticism because of your ego about your own work. Remember, you can't paint well unless you THINK while you paint.

There are prerequisites that are almost always overlooked when one decides to become an artist. The norm is to enroll in a class and or read available material on the principles and techniques of painting. This approach is akin to teaching yourself to ride a motorcycle. That's fine until you get into trouble, which is an almost certain eventuality.

However, the essential prerequisites to success with paints and brushes are the rarely taught disciplines of time-management, dedication, attention to the details of incorporating painting into your daily life and so much more that enable you to use the learned skills and techniques of the craft that can produce a successful career.

The physical skills are merely the tools for a prepared mind. Your efforts, however well executed from a technical standpoint will have no more impact on the viewer than a well-constructed chair unless it appeals on a personal level to the human spirit. It should relate to the viewer's own experience and hopefully excite the imagination.

Make nature come alive, depict the wind, heat of the sun, the snow and rain and the changes in the time of day.

Ray Strong, a well-regarded California painter, referred to nature and art in his poem. "Stop the Sun as it Rises."

Stop the sun as it rises
Paint the dawn and dusk
And into the quiet of earths shadow night

Paint the moon and the stars

Then grab the winds of midday

Chase clouds, lift the mists and face the driving rain.

Look at me

Listen to your voice within

Struggle to be true to the nature in yourself.

Before you start a painting, look for inspiration, inspiring visuals and give careful thought to the translation of your ideas onto canvas. Remember your goal: painting what you feel is as important as painting what you see.

Never lose that sense of wonder or the powerful significance of what you observe. The natural world enriches your life but never let it overwhelm what you are doing as an artist. Don't back away, meet the challenge but relish the subtleties. The obvious objects in your paintings are only the vehicles of conveyance for your real subjects: the feelings you are trying to express. Maintain a discipline towards realizing the subjective, emotional, and spiritual elements in the painting.

Use your acquired skills and learned principles to express your inspired purpose. The failure is in taking the path of least difficulty and letting the heartfelt inspiration pass. Learning takes place when you are taking chances.

Let the world beyond your immediate life move you! Look for what you never saw before. Don't sit out a single dance, that perfect song only plays once.

You will LEARN FROM FAILURE – FAILURE IS NOT WITHOUT REWARD. As the old saying goes "nothing ventured, nothing gained". If things don't seem to be working out, ask yourself, "Where did I fail?" Take a long and critical look. Rather than first look at what you just did, look at what you did previously, that may be the root of the problem.

As an artist you are really only painting for yourself. If you are painting for others, you may as well be a plumber.

PRELUDE TO PAINTING

The first thing not to worry about when deciding to become an artist is how to paint! There are a great many

things to consider before you dive into pigments. Begin to develop a habit of observing the world around you – the light, the shadows, values and colors.

You should study paintings at all levels and read available material about the art business. There are several magazines and occasional seminars about the business that are good resources. Visit museums and exhibitions.

You should decide what style of painting interests you the most. Don't pick one that looks the easiest. None of them, if approached seriously are easy.

Failure to spend an appropriate amount of time preparing will be an impediment to your progress. There are many things in life that you would not try unless you learned some things first – like simply flying or running a marathon.

The amount of time you save in trial-and-error is worth every day of preparation. There are many different kinds of study. Study of a serious nature tends to become a lifelong habit and will pay great dividends.

As the saying goes, "Dig your well before you're thirsty."

Preparation in learning the technical skills and principles of painting is essential to achieving your desired goals. You cannot capture the essence of the subject without the possession of at least the elementary knowledge of the process. The more skills you have the more successful you will be.

Before trying to learn all you can on how to paint, stop and look back at your beginnings. Don't go too far beyond what you THINK you can do. Be present in the act of painting while utilizing what you learn each step of the way.

VITAL BEGINNINGS

Once you have the basic preliminary principles and knowledge of the necessary prerequisite skills firmly under control, either by memory or in notes, the initial challenge of the painting process is in the proper beginning.

The quality of the finished product cannot be separated from the strength or weakness of the beginning. Failure to make a strong beginning will often result in incurable problems. Make a habit of concentrating on

the start of every painting else the impediment to your overall development may be terminal.

Being anxious to see the intended ultimate images, most students, indeed most painters, rush over this challenge and then wonder why they don't quite achieve their goal. This results in much frustration and discouragement. Oh, what pleasures they will miss.

Remember, only start a painting because you're excited about it's potential as a work of art. And never reject a challenge because the chance of success seems remote or difficult.

Artists at all stages should follow their heart and keep in mind that technique is only the tool that helps them reach the high goal of conveying their emotions to the eventual viewers.

Good technique never takes the place of substantive communication. It is this challenge that helps overcome the intimidation by the subject as you paint. If necessary attach a note of reminder to your easel as you confront the challenges as you paint.

Be emotionally tuned to your subjective goals throughout your efforts. Work passionately and privately

and without interruption if possible. Your paintings should not only be interesting, but alive, moving, and connect with the viewer.

OBSERVATION AND MEMORY

There is beauty in very ordinary places and open spaces. You can develop the ability to visualize and to effectively present something to the world that the general population only subconsciously thinks about.

Art is a personal commentary on nature by the artist and if successful that message is conveyed to the viewer.

Observation skills and memory play a great role in what is referred to as natural ability but is actually the use of learned skills and technical expertise. Throughout the painting process, from the initial inspiration to the completion, observation is an invaluable tool. You should look at every part of the painting. In fact at every brushstroke to be sure color value and effect are what you want.

Paint what you see and feel, not what you know. For example, there are thousands of leaves on a tree and a

multitude of color in most rocks. Paint simply, concentrate on the large shapes.

To habitually recognize those things that are preliminary to painting is perhaps the most important prerequisite skill is becoming a good painter. Being able to recall your observations is equally important. These two skills are at the core of creative interpretation of your subject. Technical knowledge and endless practice of drawing and painting is essential and always pays off in the quality of your work.

In both disciplines however, thinking throughout the process is vital in meeting the constant challenges that confront you. Only experience will minimize the challenge and allow development of creative responses.

Don't neglect the habit of using your notebook and sketch pad often.

Memory is central to our entire existence and in regards to special skills such as painting it is an absolute necessity. You cannot be distracted and thinking about anything else while you paint. That is one reason I called this little treatise *Challenges and Discoveries*.

Every color, value selection, every line, every brush-stroke, selecting the appropriate brush and technique are all challenges and require the recollection of past learning. All of the major and petty decisions in the creative process require concentration. One bad decision can alter the outcome of the painting.

You will find the painting experience not only engrossing but also liberating from the pressures of the day.

If you think about it, all good work is done almost entirely from memory. What we call intuitive thinking is actually a subconscious act of memory. This is particularly true of studio painting.

The power to retain what is observed and essential and to make a visual record of it is a valid test of our powers of observation and memory. It can be developed with practice. A good memory exercise is to develop a habit of sketching whenever you have the time or opportunity to do so, even just ideas, and then refer to them often. This preliminary exercise will help your visual memory and is sound preparation at every stage of your painting.

OPPORTUNITY AND OBLIGATION

Representational artists have an opportunity and obligation to communicate the truths of nature to their viewer. There is nothing as absolute as truth.

Look at what you do as an important, albeit small contribution to restoring quality and integrity to our chaotic art culture. The work of traditional artists always relates in some way to the human experience. This may or may not be intentional. Therein lay its true value as a visual reminder of the real world in all its forms. The connection between art and our inherent spirituality is a gift to us almost forsaken by the art world.

We are privileged to be able to be part of this process.

It seems there is an unspoken duty there, for art to reflect the relationship we have with the natural world so that it is evident to those who are too busy enjoying the more synthetic pleasures man has given himself. Such man-made distractions are eventually replaced one by another. The common and natural connection between all people is through their spirituality. The subjects of painting can be immensely complex or beautifully

simple. Consider a mountain range and a simple dandelion arising from a crack in the concrete.

Without such visual reminders in a world where fewer people experience less and less of the natural pleasures or for that matter, rarely even think of them, the very awareness of their beauty and vital contribution to our existence will surely continue to diminish.

How long will it be before no one stops to smell the roses because you can't smell plastic roses? Even plastic roses are created to remind us of the real. But what is to be remembered when the real is not a part of our experience? Even the synthetic becomes meaningless for lack of a frame of reference. To a considerable degree, isn't that what is happening? Consequently, the role of traditional realism in art gains relevance every passing day.

PAINTING EDUCATION

Seek out good teachers and criticism throughout your career. A good teacher should stand by and observe and advise, not quite direct, far less command.

Paint what exhilarates you. Quality learning also comes by way of association with other artists. The

power of observing is a must as a conscious habit. With that comes the need for a trained memory. Painting is a function of the mind more so than the hands. Mentally "paint" as you observe, everywhere. If your memory is good and you can train yourself to observe, you can paint powerful interpretations of your chosen subjects.

Remember, it is your role to interpret reality and truth. Precise copying can stifle your creativity and development. It is possible to create illusions of the truths of nature and still maintain the spiritual and emotional response you desired. This is accomplished through the learned elements of composition, form, color and value as long as the perceptions are mutually complimentary.

There is no such thing as true intuitive creativity. Some are, through life experiences, although often not consciously, possessed with greater power of observation and memory than others.

This comes into play when they delve into the visual arts. Thus they are "more creative."

Although many highly regarded painters are also very good teachers, their discourse, whether it be in casual conversation, teaching or writing, is almost

always exclusively focused on the painting itself, rather than on the thorough preparation on how to be an artist.

The realities of the art world outside from the act of producing art involves vital factors such as a positive state of mind, the handling of failure and success, general adaptation to a different life style and survival in the business of art.

Contrary to popular belief, none of that takes care of itself. The artists, at the very least, must stay totally aware of the business aspects of their career and have trusted associates in the various phases of the business to depend upon.

There are many good artists that are not adept at verbalizing and prefer not to teach and there are also teachers with great knowledge that are not accomplished artists. The latter would be the wisest choice.

A good teacher in any field can communicate information, explain and suggest solutions to challenges, and point the way. Progress for the student comes only with continuous practice and commitment.

One of the most difficult problems for many students is to rid themselves of their concern for absolute accu-

racy and learn to be creative in interpretation of form. Concern for accuracy intimidates while the search for form is liberating.

The student has to learn that a drawing or painting isn't "of something," but "is something" that has its own reality.

Representational art should not be a precise copy, but a record of personal experiences assimilated and expressed via our senses. Though we paint something that interests us, it is not the form itself but something about the form that interested us in the first place. The more clearly we isolate and distill those suggestive elements the more vivid and true the image becomes. The suggestive elements that prompt emotional responses for the artist and ultimately the viewers are primarily light, color and values.

The importance of actually experiencing nature, along with a serious study of it in order to understand and paint honestly about it, is a necessity for the landscape artist. Paint with your heart and use your mind to apply the knowledge and principles you have learned.

Don't spend time guessing. Follow the basics proven through the ages.

There are thousand of books written on how to paint by writers with their own individual viewpoints. Seek out teachers with good reputations and follow their advice. You will avoid a lot of confusion and you can change later if you feel the need.

Avoid formula painting. It will tend to lock you into habits that hinder your progress by using your comfort skills again and again.

You will soon realize the valuable knowledge gained through ventures into nature and the spirituality between man and nature. This will soon be reflected in your paintings.

Painting is a language based on the attributes of light. These suggestive elements are keys to the truth that emotion always precedes analysis in the viewing of a good painting.

THE LANGUAGE OF ART

The language of the painter is difficult to learn. Collectors and academicians can "read" the language in

a well-executed painting as an actor can read poetry. The arts of painting and writing are difficult and the unique province of those few who have chosen them as their means of interpreting the world we live in.

Painting is more than just technique. It is manifested in the conveyance of the energy, emotion and spirit of the artist to the viewer.

Most anyone can learn to read and write but few can be successfully poetic or use words to touch the senses of the reader. Likewise, there are artists whose creations truly spark an emotional response from those that see their work. Those artists have learned to use the language of art. They have used their skills and learned techniques to achieve an expressive result.

A successful painting really needs no descriptive title to tell the viewer what it conveys. As they say, "Seeing is not about the eyes, it is about the mind."

The success of representational art is judged by how well the artist is able to communicate to the viewers the emotion and energy that first inspired him. It is what the viewer interprets in terms of his own life experience that makes the work meaningful.

The artist's language is comprised of the various ways in which he uses the fundamental skills of painting.

The goal of the artist should be to create a work of art that prompts a recollection in the *experience* of the viewer. The true subjects of any painting are the subjective elements such as pain, sorrow, joy, awe, appreciation of nature, etc.

Painting is the only form of art whose attraction rests solely on the visual content within its borders. A painting must be created by and for the human spirit. It should express that spirit, nourish it and enrich it. Art is an important cerebral link to our emotions and a key to human nature.

This spiritual language is the living force of all successful traditional art and the "communicators" are those visible secrets of composition, form, color and light, These elements enable us to convey what we have seen, heard, smelled, felt and what we have even imagined through the exercise of our intelligence.

In the use of these keys to the language of art, as in writing, you should be careful not to be too "wordy". An overly complex composition or too intense color can

overwhelm your painting and lose the desired impact. The use of various types of lines can convey a variety of psychological meanings. A sharp jagged line can convey tension or nervousness while a smooth curving line can convey gentleness.

Color can provide illusions of hot, cold, light, darkness and a whole range of values that contribute to the truth and logic of your painting.

The tools an artist uses to bridge the gap between the objective (the physical images) and the subjective (the viewer's emotional responses) are light, shadow, values, color and texture. These comprise the elements in the language of art that every artist must attempt to master in order to express oneself on canvas.

CREATIVITY

A rtists have a spiritual dimension not present in much of the population. What artists record are pictures from the mind. They create images of our pleasures and desires and of the visual and emotional experiences that impacted and remained in our subconscious memory. We have the rare privilege of reexperiencing life's simple pleasures and communicating them to others.

Just a suggestion is sometimes all that is necessary but it is that simple suggestion from our reservoir of life's experiences that becomes the core of the spirituality in our work.

Creativity is at the same time a universal, elemental and mystical process. Man's artistic creativity is born of experience and is indeed a manifestation of the nature of

man. To some degree, the ability to create is a universal trait in all human beings. In fact, minor degrees of creativity are part of everyday life. The mental process of creation is often an unconscious one and passed off as insignificant.

Creating visible, credible images of the real world, as the artist does with paint and canvas, can only be accomplished with considerable training. Imagination and wishful dreams often represent unfilled desires. They can become reality only if the tools are acquired to enable that transition. It is essential that the imagination and tools are consciously developed and applied in developing creative paintings.

True creativity cannot be yours by mimicking that of someone else. The lessons others have learned are useful only as exercises for you in perfecting your own skills.

What inspires you when beginning a painting is the first challenge and is important to the ultimate result. It is the spark that lights the fire! However, never be reluctant to make changes that could enhance that inspiration. As the fire burns, let any creative thoughts that occur fuel that inspiration. Also, don't let anything that spoils or

disrupts the impact of what you have chosen to depict get in the way. YOU are the improviser—move that mountain, change that color, paint light wherever needed.

Eliminate any aspect of the scene you don't think is necessary. Think! Make decisions. Make use of your life experiences. Do not paint merely to reproduce what you see. Paint to represent what you feel about the subject. Be sure your painting rings true. That takes a disciplined commitment to the act of painting with the realization that every brushstroke involves a challenge and decision.

Again, don't be reluctant to make changes. Don't be afraid to adopt a new inspired purpose if necessary. Change the season, even change the subject if your inspiration changes.

This may sound contradictory, but remember painting is a dynamic and demanding exercise. The mind is always at work and a creative mind recognizes challenges and opportunities. Remain open to them and don't be afraid to follow your intuitive instincts. They may prove to be at odds with your goal but it is only paint, and you are the painter – change it.

"Interpretive" is the key word in creative realism painting. Your paintings should be lyrical, poetic interpretations. Avoid being too precise by not strictly reproducing what you see in your subject whether painting from life or reference material. If you are painting from memory as well, you should discipline yourself to use it for interpretive reference.

It is not easy to remain focused on the subjective emotional content of your work while painting as best as your technical skills allow. It is perhaps the greatest challenge in producing a well-done yet meaningful painting. Avoid triteness.

The same challenge exists in plein-air painting because you are naturally inhibited by the truths of nature before you. Don't be reluctant to move things around, change the color harmonies, time-of-day or whenever it strikes you to make a more lyrical statement. At the same time don't mess too much with Mother Nature. Be consistent and truthful with your changes. Be conscious of the seasons, changes in light, and the mood you want to convey.

Go for the sentiment. Keep in mind (as the poet maintains his message) what you are saying with your painted images. A well-projected statement is more important than perfection in artistic technique. To accomplish this requires the purposeful use of composition, form, color and light as well as the techniques such as brushwork.

Merely being well painted technically is not enough. Your work must have meaning.

REFERENCE MATERIAL

First of all, working from life or nature is preferred over working from reference material in that photographs distort the images and photos of paintings, almost never show the brushwork and accurate color, values or even perspective.

Use only elements that inspire you. Leave everything out that is not necessary to get your desired message across.

Make your own compositional sketch on location if possible or from the reference material available. Don't rely solely on the source material itself.

Make color and value notes or samples as you see or visualize them if you have the opportunity.

Photographs can be used effectively as aids in capturing the shadows and sunlight of the time of day if you are painting plein-air. They can be referenced as well for compositional specifics for later use as reminders in the studio. Once you've used the photos for reference, put them aside and rely on your notes and memory.

Be creative in your own concept and impression of the task at hand.

Keep an organized file of reference material. It will save you time later. Do not copy reference materials, use them only for inspiration, shapes, color and value notes.

CLARITY OF INTENTIONS

From the very beginning your paintings should have clarity of intentions. By concentrating on the basics (composition, form, color and light) with purpose, that clarity can be preserved. Evidence of your intentions will be confirmed in the responses of the viewers.

Utilize your life experiences and acquired technical skills to depict the emotional and spiritual aspect of your work.

Every stage from initial concept drawing through the last brushstrokes involves multiple challenges and decisions. Think of them as just that as you work. Execution of principles learned requires working towards successfully meeting those challenges. This is when important discoveries occur. Spend more time thinking and looking. Be critical throughout the process. Painting is 90% mental and 10% physical. Preserve your original intent. However, be aware that a possibility not anticipated may present itself at any time while painting. You may visualize a more exciting potential as you work, particularly in the early stages.

Unless you maintain the original inspired goal while you work, it may get lost in your enthusiasm with the physical joy of painting. Challenge your intellect as you paint and throughout your career. The best way to perfect your technique is to work at a deliberate pace, not at a frenzy without frequent breaks for assessment of what you have done. Every color, value and brushstroke done

without reason could result in a loss of your intended goal. Your paint should be applied so that it adds to an understanding beyond the physical visual material and supports your intended message. Your objective demands specific techniques so you must keep both in mind as you work.

Your use of technique, the language of art, should be as clear as necessary to complete the message. It should be flexible throughout the painting and adapt itself to the story.

In many cases a thoughtful, well-executed painting of the natural world should not even need a title. However, there is an advantage to titles. They can help viewers to identify with the subject and the artist's intent.

The most important factor is that the artist maintain focus on his goal, otherwise what results is an uninteresting, unemotional painting of objects. Strict interpretation of form without creative intellectual attention to the subjective elements almost always falls short of appealing to the spirit and of becoming an affair of the heart.

Once somewhat comfortable with your knowledge of the various techniques, be willing to change anything from the very beginning, it's only paint and canvas. The substance of what you are striving for is not restricted or dictated by what you physically do or have done, but is open to all options.

Never be afraid to change what you've done if the thought occurs to you because those thoughts come from your subconscious and are usually valid. However, before making the change, stop and reflect on it in terms of your initial objective.

By disciplining yourself to this approach you will, in time, reach that point where wonderful things occasionally just seem to happen, where the act of creating is highly intuitive.

Don't labor over your painting. A spontaneous brush stroke, dabs of different color or even a wipe out can result in that "bit of magic." If it works in the overall effort, leave it.

Be relaxed and happy while you work. I often sing while painting, both in the studio and in plein-air outings.

The key to clarity in your paintings is simplicity and economy of form. Even if the subject and composition are complex, the various components can be painted with degrees of simplicity, values and color so as to bring attention to the most important elements in the painting. This aids in bringing focus on the subjective content.

AVOID TRITENESS

Do not greet continuous acceptance of the same subject in your paintings as artistic success, regardless of how well done and the fact that sales may be going well. Two things will eventually stop. One will be your growth as an artist, and the second your gradual loss of sales over a period of time. It is hard to rejuvenate a lagging career. Keep your paintings and subject matter fresh.

By all means avoid triteness in your own work. There is a limitless amount of subject matter in the natural world to appeal to any realist painter.

The subjects that realism painters tend to adopt fall into one of several categories. One type of subject is of a very broad and universal appeal such as the wonders of nature. Another type includes subjects of special interest

to select audiences such as portraits, sports paintings, or still life. Less often the subject is appealing only to aesthetic pleasure in terms of beauty in color and design such as a yellow field of wildflowers. The latter type of utilitarian subject is the type most often incorporated by the modernist school and design world.

Traditional representational depictions of the natural world have universal appeal due to the common spirituality of man and our natural bond with the environment. This is the broadest category of acceptance in fine art painting and offers endless opportunity of diversification for the painter. However, all segments of it can be separated into special areas of interest.

Included in the special interest category are all of the varied ethnic and identifiable types of humanity and animals. The subcategories of the special interest are never ending.

An appreciation of beauty, I believe, resides in the nature of all human beings. It may be only in the sparkle of minerals in a stone or the pearly colors in a seashell.

It is your role and pleasure to capture such beauty.

LANDSCAPE

Landscape paintings if done well, transcend the gap between the intent of the artist and the perception of the viewer. The artist and the viewer connect in the experience and contemplation of the natural world through a finely created landscape.

Your beginning sketch in painting a landscape should be a loose compositional outline. Include the larger shapes. Here is the opportunity to develop or realize any abstract patterns that will strengthen your painting. Remember, even shadows can provide abstract shapes within your composition. This provides an opportunity to establish solidity to your composition that will save you time and worry later. Create mass (including subject forms) simply and use values of your color and value patterns to identify shapes. These relationships, more than any line drawing, help develop perspective, form and scale.

Discipline yourself to see mass, color and values instead of objects. First paint the essence what you see.

Paint shadows and values first. Don't be involved with detail yet. Follow up with your lighter value areas.

Beautiful color without appropriate values will not result in a good painting. A monochromatic painting with strong values will hold up. Stop now and take a good critical look at what you've done.

In landscape painting as well as other genres, the decision regarding detail is dependent upon the style of painting. If you paint in a painterly style rather a tight or photorealistic style, then your attention to detail is decidedly in concert with your style.

Being carefully selective in composing a landscape is an aid to creative compositions. You do not need to include everything before you. Don't hesitate to edit or relocate forms to enhance the composition. Don't go out and look for a familiar subject or scene—you probably walk by excellent subjects a hundred times looking for just the right one.

Also don't look for subjects that are in your comfort zone that you've painted many times before. You are not painting for the masses; you are painting for yourself. Quality will come with meeting new challenges.

Don't just paint a picture, have a subjective attitude towards you painting.

Paint the light.

Paint the shadows.

Paint the wind, rain, dust, etc.

Paint the rushing, bubbling waters, the pounding surf.

Paint the glory of Spring and Autumn.

Paint the cold and heat of Winter and Summer.

Paint the miracles of the natural world.

Such are among the subjective elements of your paintings versus the objective physicality of forms. They not only provide visual drama but more importantly, a spiritual connection with the natural world. Think about that connection while you paint! It will elevate your painting to a higher level.

The keys to achieving your goals in a work are in constant, focused observation wherever you are painting.

It has been said that, "Chance only favors the prepared mind." I want to emphasize once more that seeing is not about the eyes, it is about the mind. To paint and translate what you observed and filed in your memory, you must paint in a controlled state of mind, combining conscious exuberance and purposeful restraint.

Avoid triteness and trends. Both are avenues in search of rewards either financial or egotistical and you run the risk of leaving your artistic soul by the wayside. They are roadblocks on the path to your artistic identity.

Avoid too many details, just hint at them. Squint at your painting as you work on it. This will help tell you if you have overdone it. Detail helps you judge your perspective. The further away the object, the less detail there will be and the less intense colors will appear.

The greatest detail and the most intense color should be to emphasize your primary subject. That is true even if your subject is non-objective i.e. the elements such as weather, sunlight etc. Trees and other forms should be mostly silhouetted using large light and shadow areas. Don't break them up.

Avoid painting every leaf. Indicate depth as darker values in the foliage.

Avoid "airborne objects" by the proper use of shadows, ground cover or whatever works without looking contrived or disrupts the composition.

Note, the reflections in water are lower in key than the object reflected.

Look for abstract patterns in secondary forms as single subjects i.e groups of trees, rocks, houses, etc. Treat them as one—a mosaic.

The wonders of nature bring in every moment a picture never before seen and which shall never be seen again.

Recognize when and what you see that elicits an emotional response within you. It may be slight or extreme and stop you in you tracks. These experiences are what you should focus on as the subjects (truths) in your paintings. Look for the drama in the scene.

PLEIN-AIR

Plein-air landscape painting requires a selection of subjects and arrangement of forms within the borders of what you've chosen to paint. Always be looking and take time to respond to your emotion. Next, analyze the potential for a painting to express that feeling. Remember, your response was the result of the subjective factors of light, shadow, color and atmosphere upon or around the objective forms within your purview. Think of it in such terms and represent them in your painting. Simplify. Be

selective. Diminish or eliminate obvious but unnecessary forms and details in your composition.

Discover the abstract potentials in your composition that will enhance it. Intensify the emotional impact elements that enable you to best convey what it is you want the painting to say to the viewer.

Contrary to some thought regarding plein-air painting, there are times when parts of the scene in front of you need to be moved or changed. This facilitates an artistic interpretation of what interested or excited you about the subject in the beginning. Don't overlook such opportunities. It is your chance to be creative and still be true to the scene.

The importance of plein-air painting in preparation for doing large work is commonly stressed. More important is the development of your powers of observation and memory. You will always have them with you. Think of those momentary inspirations as a charter for what you intend your eventual painting to be and hold that inspiration. Even as you proceed with your original intent, the mood of your work may change. If necessary, refer to your notes and sketches to retain the original

intent. Don't change your direction due to a roadblock in your original vision unless you really feel the change is for the better.

When painting outdoors you can use the subjective elements as well as objective forms as important parts of the composition. The use of light, shadows and color as well as the various moods created by the hour of the day all offer great opportunities for creativity moving beyond mere replication of what you see before you.

Moving and introducing forms into your composition (such as trees, distant hills, clouds) can turn a mundane but interesting scene into an exciting painting. Changing the season can be just the difference between ordinary and beautiful.

All of what I have described can also put drama into your painting.

The challenge of creative thinking makes painting exciting and satisfying. Without the challenges, painting becomes a task rather than a pleasure.

SELECTIVITY OF SUBJECT

Selective interpretation of a landscape can suggest elements of nature by the use of shapes, color, and values to imply rain, snow or blowing wind. You should avoid details such as individual leaves and branches where possible and leave other details not essential to the scene or your subjective motive out of the painting. Your painting is finished when your statement is made.

A simple message carried by a simple composition can be a most effective communication of the subjective elements in your painting. The challenge to select the key elements important to that message will keep your work true and fresh. If an element is unnecessary, leave it out.

By successfully creating an emotional response to your painting, emphasizing the subjective elements rather than including all the objective forms, you have provided a suggestion of another dimension for yourself and the viewers.

Select matter-of-fact subjects and/or elements about them that have potential for creative, emotional and artistic interpretation. Always look for inspiration and

what the subjective elements represent rather than the physical aspects of the chosen form in the composition. Objects and form attract the eye and creative subjective elements attract the imagination. Enhance those subjective elements if necessary to communicate your inspiration.

As a painter of traditional realism, be true to the time-tested concepts of composition, form, color and light.

Always look for the challenges.

THOUGHTFUL CHOICES

Most budding artists know or have in mind what they want to paint before they make the decision that leads to action. If not stirred by exhibitions of traditional art, they are generally enticed by what others have done or by a specific subject interest. The latter interest is usually best served with a camera if an honest interest in painting is absent. The life-long struggle of creative painting is thus avoided. The tendency of focusing on a specific special interest is to let the subject become the controlling factor rather than the challenge of creativity.

Whatever the subject, what is essential to produce a work of art is a disciplined awareness that the emotional response to beauty is one of the primary keys to success.

This is the difference between illustration and fine art although there have been many illustrators who have produced work that is certainly fine art.

Having said that, perceived beauty is a key element in determining what to paint. A sincere, or better yet, a passionate interest in the subject is often reflected in the end result. Don't let subject alone dominate your work— you must still communicate the subjective elements using your favored subject as the vehicle of conveyance.

SIMPLICITY

The finished painting should reflect a simplicity and economy of form. Even if the subject and composition are complex, the various components can be painted with varying degrees of simplicity.

Color and values should be painted so as to bring attention to the most important elements focusing on the subjective content.

Here the challenge of simplicity aids in maintaining discipline in the process of achieving your goal. Decisions such as this will always result in discoveries, slight and grand and make your painting effective. There is power in simplicity.

The judicious use of abstraction can also be a powerful tool in focusing on the subject and giving the illusion of simplicity to the composition.

Meeting all of the challenges as you learn and work, requires making decisions that often lead to important discoveries. Remember them. Make notes if necessary. You will only have to refer to them several times before they become a part of your practice.

Get in the practice of adhering to the KISS (Keep It Simple Stupid) method. Include only those things that are essential to convey your message. Think about the essentials as you work. Resist going back and messing up your canvas by making changes. It is better with a strong, simple foundation to work from.

The key to simplicity is to decide first what you want to say and what the challenges are and how you intend to meet them. However, being simple is not easy. Begin

with a solid foundation. Don't get ahead of yourself. Stop, step back at every significant step and criticize what you have just done. As you learn, time looking is time well spent and as important as time with the brush in your hand.

Remember, your main goal is to focus on the subjective impact as opposed to the objective elements of forms to convey a message of truth in what you depict.

CREATIVITY & CONFORMITY

Conformity can kill creativity by lessening the challenges from which you learn. Don't get in the trap of painting what you do well over and over and over again. The catch-22 is that you must first learn to paint well. This is done through preparation, thinking and focus on your craft.

While conformity often kills creativity, too much diversity can hinder commercial success or acceptance when an artist tries to paint too many different subjects or styles before he fully learns the techniques that further his accomplishments.

Yet, unless the artist's chosen subjects are those for which he has an intense interest, the works will be less than inspired. Repetition results in boredom for both artist and collectors whose intellectual interests are varied.

Inspiration comes with some personal connection to either the subject or what the artist conveys through the subject. The manner and skill with which the artist gets his message across should be judged on its emotional impact not on something he has painted a hundred times before. Repetition shows no creativity or imagination.

Unfortunate as it is, some collectors and dealers find easier acceptance of art when the subject matter is overly familiar or if the meaning of the painting is self-evident.

This speaks volumes about the influence of commercialism in the art market.

WHAT TO PAINT & WHY

The importance of what we choose to paint and why we paint it turns out to be the determining factor in the success of our choices. Do not waste time, even on exercises, without a solid reason for doing them.

The beauty that inspires us is always contained in the endless variety of shapes and scale relationships, coupled with the colors and values that provide the subjective elements in the scene. As artists, we try to capture the emotional context of all that.

Don't paint merely for subject matter, i.e. ships, rivers, horses, etc. simply because of an intense interest in them. If a dealer tells you he can sell as many as you can paint, you may become known simply as "a ship painter." Soon your growth as an artist may come to a screeching halt.

Regardless of the quality of the selected theme, you may eat better for a period of time but be much less fulfilled.

Don't be ordinary or usual in subject selections. Before you start, look for inspiration, inspiring visuals and think how to translate them onto canvas.

Never lose that sense of wonder or of the significance of what you observe. The natural world enriches your life but never let it overwhelm what you are doing. Don't back away, meet the challenge, relish the subtleties and the emotional/spiritual impact of your inspira-

tion. As you work it is difficult to maintain that focus. Discipline yourself to do that.

Use your acquired skills to express your emotions. The failure is in taking the path of least difficulty and letting heartfelt inspiration pass. Learning takes place when you are taking chances.

ORIGINALITY

To be influenced by other artists' work is very common and useful practice in your own development, as long as you remain creative in your own work. If the influence is profound you may want to adopt a similar style, but do not copy the work except as an exercise.

Repeated copying can inhibit development of your own creative skills. The challenge then becomes that of retaining your own originality, particularly if the work or even the style copies is that of a well-known artist. You may run the risk of losing your own identity as a creative artist.

Recuperating from a reputation as a copyist is problematic at best, although there may be some temporary financial rewards. Further, most galleries are reluctant to

handle artists that are obviously closely copying another's work.

The consequences of deviation from the logical construction and process of painting are in not meeting the expectations and in further frustration. Stand back and consider what you have done and make corrections directly. Often what looks wrong is not the problem but rather something done before is making the last addition look wrong. Be very critical of the entire work up to that point. Errors left uncorrected usually compound the problem by presenting larger ones. Think and work through the challenges.

Concentrate on your own development. Nothing succeeds like success.

PRECONCEIVED IDEAS

Always keep an open mind regarding your interpretation of the subject. I have frequently heard students say, "But, that's the way it is." It is a most common preconceived notion that nature always offers everything in the right place for a good painting and that the camera doesn't distort images. If that were the case, there would

be no need for painters. If you remember your preliminary studies about painting, you will realize that such strict preconception of reality is often a hindrance to artistic creativity.

As Robert Henri wrote, "...you should free yourself from your own preconceived ideas...and take your head off your heart and the give the latter a chance."

If the student pays attention to the principles of composition, form and light, the restrictive aspects of preconceived concepts will give way to creativity.

Whatever preconceptions you may have regarding your subject as a whole, you may experience questions and/or shifts in your intent that may be adopted in the painting process. When considering these, focus on what you *feel* about the subject with an *open* mind rather than sticking steadfastly to preconceived ideas or conversely, recklessly leaping into the unknown without careful consideration. Use your head. Again, painting is about thinking as much as painting.

REALISM

Why are artists drawn to traditional realism? What is the underlying source of their creative motivation?

We are all aware of the obvious conscious inspirations that set our minds and physical senses in motion towards a conceived goal. Once that goal is met, your painting will forever thereafter be fodder for the critical mind, yours and others. By its very existence, it represents to some degree, truth and in truth there is beauty.

Visual perceptions prompting the artist's observation of beauty or form inspires them to represent it in their work. Spirituality on the other hand is that mostly subconscious influence that compels them to interpret the beauty perceived.

It is that spirituality, that connection to truth, evidenced by life in the natural world that should motivates the traditional realist painter.

The truths inherent in realism painting can be achieved through a wide range of styles as long as the goal is achieved through interpretation of reality. A painting of a shadow on a wall can be very expressive. A shadow image is universally understood. It can evoke

fear, passion, and motion and, of course, the suggestion of light. It is a non-existent thing in terms of form but can elicit a wide range of emotion.

Universal understanding of the subject is there even if some may need to be prompted by comment. However, in most cases a thoughtful well-executed painting of the natural world should not even need a title. The most important factor is that the artist maintain focus on his goal, otherwise, what results is an uninteresting, unemotional painting of objects.

Strict interpretation of form without creative intellectual attention to the subjective elements almost always falls short of appealing to the spirit and of being an affair of the heart.

STATE OF MIND

A s you begin to paint, keep in mind that, "It is the grey matter that matters." We are speaking, of course, of the brain. Painting is ninety percent mental and ten percent physical. Creativity continues throughout the periods of inspiration and execution. Imagination and intuitive inspiration are important individual tools and you should take advantage of them, all the while maintaining your goals.

While not in the studio or at the easel outdoors, the most valuable state of mind is to always be observing the environment and remembering or taking notes if necessary for future use.

As an artist, another important state of mind is to not be afraid of failing. Realize that failure is an important

aspect of learning. Also, intuitive inspiration comes from your subconscious and is not a manifestation of genius.

It is important that you ask yourself, is your state of mind focused on a desire for recognition, recreation, financial reward, social relationships or other reasons? As a realist painter, is there a deep emotional reverence for what you paint? Whatever your reason, a serious and disciplined preparation cannot be overemphasized.

Your feelings should be expressed by what you produce. Does such feeling exist across the board among the extremely talented and lesser so? It probably does, but I suspect more naturally and profoundly among the more gifted.

Artists whose work transcends mere ability must indeed have a profound understanding of nature. Such understanding requires either personal experience in nature or serious study of the subject.

Make your choices. Put feeling, heart and soul on your canvas. Don't just apply paint on the canvas representing your favorite subject even though it may be a well-executed painting exercise.

Good technique alone does not assure a good painting. Neither does the accurate representation of form. It is a long journey from the brain to the heart. To accomplish your goal requires the difficult discipline of capturing and maintaining your original inspired vision. Of course, you must be prepared to recognize that it was probably the subjective elements that actually inspired you.

Each step of the painting process should be aimed towards achieving the subjective impression you began with. The physical objects in the composition are only the messengers used to convey your original inspiration. That initial spark of inspiration was actually a spontaneous and perhaps subconscious response to color, light, or perhaps forms that prompted recollections of experiences.

Your first sketch and accompanying notes should be simple references of your concept. Even make them on your canvas if necessary.

Spontaneous improvised changes added as you work are intuitive and should be given careful afterthought. If your mindset remains on your original goal they generally are beneficial to your painting.

PASSION – THE ESSENTIAL

Technical mastery of the medium and intellectual knowledge of the craft will not assure that the artist's efforts will result in a work of fine art. What sets apart one artist's outstanding artistic achievement from others, is the evident passion the artist had towards the work in creating it.

That passion visually manifests itself in the end result. In such cases, emotional reaction to the work always precedes analysis. That is a sure test.

For the artist, that passion unfolds in an unpredictable but conscious state above mere inspiration, coming from a reservoir of knowledge and acquired skills. In such a state of mind the mechanics of the craft become automatic, time irrelevant and achievements occur beyond the usual.

When this period of discovery and excitement wanes, you should stop and review the results and impact of what you have done.

It is entirely possible that an unfinished work done in a passionate state of mind could be your best.

WHERE IS YOUR PASSION?

What kind of artist do you want to be? Where lies your passion? Perhaps you haven't developed your interest to the extent that you are sure. If you take a disciplined approach to your endeavors while you are studying, the passion will come. It may result from other than the act of creativity. Your primary interest may be academic, or as a collector, or as a lover of the arts.

I hope some of the insights present in this book will help inspire your passion for the visual arts regardless of your field of interest.

Is it the subject that entices you, the challenges of creativity or the joy of a recreational pastime? Each has its merits. Your passion may be more pure than any of the above. It may be so pure that you are actually at a loss to describe it. If so, it must be a personal association, conscious or not, fueled by your desire to create, collect, or enjoy images inspired by our shared connection with the natural world. If that is the case, there comes a time, albeit rarely, when you will be hit with the realization of such an awakening and you will look at what you have experienced with a high sense of satisfaction.

LIFESTYLE

To try and define the professional and public image of any given artist is inevitably tied to their reputation and success of their works. The initial success generally comes in different ways. The usual measure is one of financial success coming regardless of style after some level of real artistic achievement and promotion. Recognition and some level of promotion can, conversely, come through success in established shows and exhibitions.

The lifestyle of the individual artist should not be a true measure of their status in the art community. Whether you live simply or in a castle, dress flamboyantly or from a thrift shop, your work will be what defines you as an artist. Don't succumb to the temptation to yield to situations that soak up time and energy but do little more than provide a few dollars and add few, if any career opportunities.

The question of individual persona as an artist in dress, behavior and personality is a matter of choice but is meaningless in terms of artistic achievements.

Thomas Eakins, one of America's master artists was raised and kept his studio in a sophisticated upper middle class home and yet was very casual in his personal life, not befitting his status in the art community.

A number of artists have successfully parlayed financial success and notoriety to where their acceptance by society is self-perpetuating. It seems odd that you rarely see an objective critique of the art at this stage. The emphasis is generally focused on the artist as opposed to the art itself.

Recognizing that it takes a considerable ego to be or want to be an artist, and that it sounds good to hear some entrepreneur tell you how he can sell your work, this practice of false hope is grossly unfair without the supportive evidence of quality and demand. Otherwise, it is unfair to the artists, the collectors and the galleries themselves to foster off work that is of decidedly less quality at high prices. Unfortunately, too many artists and collectors have proven to jump at the jingle of silver.

SELF-CRITICISM

Don't limit your achievement by having too great an expectation without sufficient accumulated skills and knowledge. The creative aspect of painting is a continual process of thinking about what you want to do, what you are doing, and what you've done. Never be completely satisfied with every painting. Be the devil's advocate about your own work.

There are two important aspects to self-criticism. The first and basic step is to consider whether the work is skillfully executed and that the technical matters of composition, color, and light are deftly handled. Second, is whether the painting is saying what you want to say. This practice is important throughout the process, from the time of inspiration and conception until the finish. Your results should reflect and keep alive what initially inspired you.

Losing your focus can ruin a day's work. Write down what inspired you on a note or make a small sketch and tack it to your easel if necessary. Remember that what you do is visually communicating the images just as writers and musicians do with words and sounds.

Don't paint to be satisfied. Paint for artistic success. What satisfies you today may not look so great a month from now.

An important part of being self-critical is being objective in comparison of your work with others. Look for why other art succeeds, not just that it does. Analyze it! We sometimes tend to look at poor work and decide ours is better. WRONG APPROACH! Look for important elements that could make that painting successful.

Let your emotional response to the chosen subject be the guiding factor when you are painting. Make all the necessary preparations ahead of starting to paint. Maintain that inspiration and let that "feeling" guide you to an avenue of greater enjoyment and achievement.

Good works of art are those that combine a conscious maintaining of the artist's goals with the technical principles of painting.

After a day of intoxicating creativity, how will your efforts look in the morning? Plan ahead as you work. Don't ignore the essential development procedures. It is not unusual to get lost in the technicalities of painting and forget the emotional goals you set out with. This is

the reason why you should step back often and study what you have just done. Even to the extent of spending as much time looking as you do actually painting. Time spent analyzing your work is never wasted.

During the pleasurable and sometimes intuitive periods of painting, when things just seem to happen, it may very well be best to not interrupt your work to examine or critique your efforts. Keep the energy flowing and fresh so that the original inspiration continues and grows into a natural translation. If you are on a roll, stay with it.

However, if there is something that just doesn't look right to you, or when the intuitive state passes, stop and take a critical look at what you've done.

If you don't immediately see it, then visualize what change is needed. It may take a single brushstroke or an afternoon of work.

Granted, in order to do this you must have a reasonable command of the principles and techniques of your craft. At whatever level your skills are they will look labored and overworked unless you hang onto your original idea and just do it!

Your instincts and learned skills will guide you and tell you when you make an obvious error.

With every challenge encountered there is always the possibility of frustration when you cannot immediately accomplish what you want to do. Acknowledge that when the challenge is a new one, it will result in growth and that growth by nature is generally slow and that progress almost never fails.

It may be a good time to return to your preparation notes rather than try and work your way through it. The latter might result in losing the essence of what you have already done.

Failure is nearly always rooted in lack of knowledge. If we were greater than the problem there would be no challenge. Growth through discovery provides the answer.

With the practice of logical problem solving the number of problems encountered will gradually diminish, and your growth enhanced. You are never defeated as long as you are willing to learn.

There is great and lasting value to time spent in serious work. Schedule your time without distractions.

Every activity while painting requires thought. Every brushstroke and color selection represents a challenge that affects the ultimate outcome. Energy wasted on other activities or interruptions is not available to you and if you wear yourself out through unrelated demands on your psychic nature you cannot expect to function efficiently as need be for an artist.

It is important to keep one's mental faculties active as a secret to longevity and good health. It points out the need for self-control, discipline and a personal philosophy within which you can work in a positive state of mind.

There is another area in which self-assessment is of considerable importance. That is one of assessment of your state of well-being. The simultaneous development of the artist's positive state of mind is as vital to the ultimate success of his labors as is adeptness with brush and paint. A constantly frustrated mental state always works against the free exercise of your craft. There are many frustrations. Thorough preparation as discussed previously, both at the beginning of and throughout your

career, is the surest way to maintain confidence in what you do.

There is no substitute for a prepared mind and that preparation must be done ahead of time to gain confidence as you work through the many challenges encountered.

An honest assessment of your physical health on a regular basis is also of vast importance to your career. The more we worry, the worse we feel and the more fatigued we become. Even though our principle source of energy is our psychic nature we must be internally healthy if we expect to have a constructive career.

While painting, if something stands out and looks in some way wrong, either in form, color or value, don't try to immediately correct it. If you painted it as you believe you saw it, or from reference notes made previously, it may well be correct.

Your first step is to look carefully at adjoining areas that may not be finished or painted. Until approximate color harmony throughout the painting is established a single finished area will stand out unless there are proper relationships to the rest of the painting. This is the reason for painting all of the main shapes and general values and

colors, in particular the darker and shadow areas before beginning to finish the piece. This is where the abstraction in your composition becomes important.

This is a difficult task in the process of self-criticism. Do not isolate your effort with something you are comfortable with and then adjust the rest of the painting.

Remember, time spent looking rather than painting is just as productive as time spent with a brush in your hand. You will save valuable time adjusting.

Understand what makes a successful painting, yours or anyone else's.

Regarding your own work, know where you are as an artist. Only then can you grow. Don't fall into a comfortable niche because some one thing works or sells.

Being an artist means adjusting to failure. Get used to it! The joy is in the challenge before you. Enjoy each accomplishment and don't hope for a masterpiece.

ARTIST'S CHARACTER

It is important that artists possess certain traits and bring them to bear in their work. These traits should include:

THE MARKETPLACE

T here has always been a market for representational art and that market has had a resurgence in recent years. It is up to the individual artists to engage themselves in promoting and becoming part of that resurgence.

For all levels of work there are a multitude of opportunities to showcase your work. They include local shows, street festivals, art associations, galleries, major annual shows and museum exhibitions.

What is essential is to be realistic about your own work and where you fit in. You could be less confident than you should be as well as a bit too egocentric. Be governed by honest evaluation of the quality of your work, not by what you think it might be worth. Don't compare prices with other artist's work. Compare quality.

Everyone starts somewhere near the bottom of the ladder depending on the degree of preparation you have done and sometimes what name recognition you may already have from previous endeavors. For instance, someone with a degree of celebrity may sell more paintings initially in spite of his degree of *artistic* success than someone with a smaller social circle. This doesn't mean that person's work is better than someone else's just that the marketplace can sometimes place an emphasis on factors *other* than quality of the work. Prioritizing the quality of your work is the only true measurement of artistic success.

Of the several levels of acceptance that you may ultimately experience during your career, the first comes shortly after you begin to paint. At this time your friends, family and co-workers will almost always express support and admiration for your work and wish they could do it themselves. What a wonderful appetizer for your ego. You can't help but anticipate more wonderful courses to come as your skills progress! But you must maintain a sense of reality. It is always not a bad idea to make a

habit of asking your trusted artist friends to critique your work and accept their comments with an open mind.

If you are a traditionalist painter keep in mind that your place in the art market is to a large extent based on reputation as well as the work itself. Don't let your desire for success determine your course of interest and get ahead of your level of skill. Work hard. Be true to your craft and to your goals.

There is an old, Russian proverb: "When money speaks, truth keeps its mouth shut." Don't confuse economic success with true artistic accomplishment.

GALLERY RELATIONS

An artist's relations with a gallery are a multi-faceted challenge. How does one begin if you've never presented your work in galleries before? Have you sold your pieces privately to friends and relatives? Do you show your work at Arts shows? Dealing with galleries is a big step up and there are a few things to consider going in.

As your work improves and progresses you may outgrow some of your galleries but it is always a good idea

to keep an eye on your constantly evolving relationships with your galleries.

We'll touch on how to find a good gallery and what to look for. You'll need to know how to price your work and how to approach and communicate with an experienced gallery owner. We'll cover all of these things and more.

WHAT TO LOOK FOR IN A GALLERY

The key to the selection of galleries who will sell and show your work is one of most important decisions you have. Make sure they are of good reputation, enthusiastic and productive. How does one assess potential galleries? Begin by talking to experienced artists of similar style and visit galleries locally and anywhere you go. When you do stop in, look around and ask them questions. Talk to people that you know who buy art and ask their opinion. Where do they buy and why? Check out the promotional presence and activities of galleries via their websites and ads in the art magazines.

A successful relationship with a gallery is based on the quality of your contact with them as well as the

quality of your work. If a gallery is enthusiastic about you as well as your work, they will want to put effort into the development of your career over a period of time and escalate your prices accordingly for the benefit of all concerned. Conversely, it is also important for the artist to show support to the galleries as well, to help encourage a good working relationship.

EVALUATION

When people first view a work of art, emotion always precedes analysis. This is true for the artist as he paints as well as for anyone viewing the painting when it is finished. The response works in favor of both. An emotional painter is often an intuitive painter and as such paints emotionally. Such paintings usually need less analysis as the artist becomes more accomplished.

Observers of a finished work are less likely to be trained but should be encouraged and directed to examine the composition, color, light and techniques such as brushwork in regard to the subjective elements' impact on their response.

Examination of these factors is an important part of your own critical assessment as well. The better informed your collectors are the more your development will be advanced.

Good work speaks for itself, and technically mediocre work can be a hindrance even though there may be temporary success.

Beware of unwarranted praise from those who have something to gain from it.

Placing value on your paintings is one of the most important decisions artists can make as they present their work for sale. Most often the output of a full-time artist with some level of recognition and established price structure is mainly in medium or larger size paintings.

Commitment and sacrifice are part of what it takes to be an artist. At times when the economy is weak or personal circumstances are such that your larger or higher priced paintings are not selling and you are considering lowering your prices, please reconsider before doing so. It is not a prudent practice as its effect on the future could be detrimental to your career.

Rather than reduce the prices on your larger paintings, paint smaller, lesser-priced ones. If your quality remains consistent, your reputation will remain intact and buyers will acknowledge it by purchasing the lower-priced "jewels" by an established artist.

When the situation improves you will likely be able to recover your former circumstances in the market. Avoid the devaluation of your hard-earned talent and established reputation.

For the part-time painters that are in a mid-career situation, the challenges of fairly evaluating your paintings is an evolving work in progress. The question is one of careful assessment of the marketplace and where your work fits in. This is an ongoing process and one that many artists tend to rush.

PRICING YOUR WORK

Next let's talk about pricing your work. Too rapid an escalation may greatly increase the potential of reaching an unsustainable level in other galleries representing you. When that occurs, an entrepreneurial dealer will naturally look for another "amazing talent" to promote

and you will struggle with the unrealistic price structure created. Remember your reputation suffers more if you need to keep lowering your prices than if your prices rise with the quality of the work.

The artist should control his painting's prices with serious consultation and consideration of input from all of your galleries in an effort to keep all parties realistic and with a shared focus on gradual growth and continual sales.

There are several schools of thought on the matter of pricing. The easiest and most common practice is to develop a pricing scale based on the square inches of canvas surface. This is only truly valid if each painting considered is of equal quality, which is seldom the case.

Pricing your paintings on the basis of their quality is the most important and realistic place to begin discussion for all concerned. You should always discuss the artistic merits of all your paintings with your gallery so that they can convey that artistic expression of the artist to the potential buyers. But do not forget to listen carefully to your gallery's impression of what they see as the artistic merits of your piece. You may be pleasantly sur-

prised at how an outside opinion can refresh and enhance your own perspective. You may never 100% agree on the merits of each piece but you will be better equipped to find a pricing solution that works for both of your needs.

Realize that if you are in a realistic, non-inflated nor deflated price range for work of the quality you are showing, the buyers will generally purchase art that appeals to them esthetically and emotionally anyway.

BUILDING A GOOD
GALLERY RELATIONSHIP

Communication is the cornerstone of a good relationship between artists and the galleries that represent them. Some artists work under the assumption that it is the gallery that bears that responsibility. Not so. The interests of both parties can best be served by a policy of regular communications on both ends. Such routine considerations often will avoid unstated concerns by both parties and aid each in keeping the relationship fresh. The goal is to maintain a mutual confidence in one another.

One important factor in a regular communication policy is the mutual linking of websites, thus providing

more exposure for everyone. The reluctance of some artists to link to their galleries for fear of interested collectors contacting the gallery and purchasing another artist's work is really almost unfounded as is the concern of a gallery that a client would go direct to the artist bypassing the gallery. If there is not a high level of trust between both parties, you should not be doing business together.

Whenever the artist discerns that the buyer's source was the result of seeing the particular piece at a gallery, he then has an obligation to honor the relationship of trust and include the gallery in the deal. That obligation under such circumstances can be included in the consignment agreement with the gallery. We'll discuss contract agreements in more detail in a moment.

Stay in contact with your gallery. Establish a pattern of communicating with your galleries on a regular basis. Even it is only to let them know what new work you may have for them. But don't become the one artist who continually disrupts their day with relatively unessential outreach. Remember they have a business to run and you aren't their only priority. You wouldn't want unneces-

sary calls from them every time you were in the middle of an inspired moment of painting, would you?

Be friendly and personable, but keep it short and to the point. A warm personality and respect for other's time and opinion goes a long way. E-mail is a great way to be non-disruptive. If you don't hear from them after a couple of days, a quick call to make sure they got your e-message is appropriate.

In today's culture, electronic networking is the fastest and easiest way to get your name out there. Developing visibility via the Internet is something galleries love to see. Collectors, presenters, patrons and fans love getting a glimpse behind the creative curtain, sharing the experience by being a part of an artist's world. Isn't the emotional connection and shared sense of humanity one of the big motivations behind why we create in the first place?

Utilizing networking tools such as Facebook and LinkedIn, posting comments in art chat rooms and discussion groups, blogging and building a good personal website are just a few of the available elements to increase your name recognition in the marketplace. Even

just brief statements about art, life, nature, upcoming exhibits or movies and TV on art… whatever your interests mentioned or linked via Twitter can keep thousands of people plugged into what is going on in your creative sphere. It's all about networking and name recognition.

Even adding the URL for your website and your networking pages to the automatic signature that appears at the bottom of every e-mail you send is FREE advertising. It drives people to your page. It takes five minutes to set up. There is no reason to NOT do it.

And don't forget, showing enthusiasm and an appreciation of the gallery's presentation of not only your own work but of the work of others on their walls goes a lot farther than always being critical of how they do things. And be sure to promote your gallery associations whenever appropriate. Add gallery links to your press releases, website links page and wherever else people will see your presence on the web.

Remember, if the gallery reps don't like YOU, they will be less inclined to promote your art.

Keep up on shows your galleries have for other artists year round and attend them whenever possible. Talk

them up even when you aren't their present focus and they will remember your enthusiasm. But be sure to not attend someone else's show and heavily pitch yourself on *their* time. You wouldn't want them coming in and selling themselves at one of your shows. Be subtle but visible. There is a fine line between pushy and present. Straddle it.

Volunteer to share resources, contacts, mailing lists with your gallery. Networking is the key in the business side of art. Maybe even call them or drop them a quick line on their birthday. You'd be surprised how a little attention towards them keeps YOU in their mind. This really helps when someone walks in the door and your name is on the tip of your gallery owner's tongue.

Make yourself visible at art shows, conferences, exhibitions and important social events. Your attendance allows you to mix with a wide variety of people you may not otherwise meet.

All of these simple steps help you let your gallery know that you are concerned with their success as well as your own. The harder they see you working toward success, the harder they will work as well.

CONSIGNMENT AGREEMENTS

A consignment agreement between artist and gallery is an important concern for the protection of the interests of both parties. As well as defining the expectations and responsibilities of the artist and the gallery, it is the absolute best way to avoid potential misunderstandings and poor relations if all comply. They are legal documents if properly executed.

Every artist hears horror stories about unsatisfactory experiences with unscrupulous dealers. 90% of these can be avoided by doing your research when choosing your representation and by carefully going over your consignment agreements while negotiating them and again before signing them.

Every State has their own Consignment Legal Forms and although there are some differences, most of them are very similar and pretty cut-and-dried. Such items as financial terms, period of consignment, cost responsibilities, promotion, liabilities, etc. are all usually included in the forms. But don't presume, check before you sign. It is general practice for all galleries to retain the right of refusal on any work offered, due to subject, quality, price

or other reasons. Remember, their decisions are based on salability and career potential of the artist.

Sample copies of agreements are available via the Internet.

At minimum, these agreements should include:

- The scope of the agreement
- The duration of the contract agreement (i.e. how long they will display your work).
- The gallery's liability for damages to the art.
- The inventory of specifically consigned work.
- The retail prices of consigned works and the scope of negotiation power the gallery has with potential buyers.
- The gallery's consignment fees, pricing and terms of pricing (including if they negotiate a price change with a potential buyer from whose share does that lower % comes).
- The method, process and timeliness of paying the artist.
- Which party pays for shipping of art.

- The accounting method for payments, consignments etc.

- The Gallery's duty to post notice of consignment, which will protect the artist in the event of bankruptcy.

- Any issues relating to promotional responsibilities, copyrights and duplication rights.

FRAMING ART WORK

One of the challenges confronting you as an artist is the decision of whether to frame your paintings and put them up for sale. First, be very critical of every painting, and don't be anxious to offer every painting you do.

Framing can be quite expensive. Only frame your best efforts and frame compatible with your painting and price structure. Don't over frame. An expensive frame will not help a weak painting and a poor selection will have a tendency to weaken the impact of a good painting. It is important to frame appropriately for subject and style of your work. As you progress in your career you will want to use the best quality frame you can afford. It

is a good idea to seek advice from professional framers or experienced gallery owners.

A well-selected frame will enhance the art and will bring out your intended vision.

Some galleries prefer to frame the consignments themselves and recover their cost when the painting sells. This also provides the incentive for them to sell the painting.

As said, good frames are an expense for every artist and deserve special handling. Unless they are on display, there should be protective corners and some protection on the frame and painting. Galleries do not like to see damaged or repaired frames submitted by the artist. Framed painting should be submitted wired and ready to hang.

It is the artist's responsibility to ship the painting in secure packaging to the gallery. It is, in turn, the gallery's responsibility is to ship the painting securely to either the buyer or back to the artist. All shipped paintings should be insured. All shipping issues should be a part of the consignment agreement between artist and gallery.

DISPLAYING PAINTINGS

If you submit your best work and it is accepted by a gallery, it should be displayed in the most flattering way possible. Optimally, it should hang on a wall where it can be easily seen with sufficient lighting. Sitting on the floor against the wall does not present a positive image of the painting.

You can get an idea how they will display your paintings by visiting a gallery and observing how it impresses you.

There is value beyond the monetary in showing and displaying your paintings. Otherwise, it is very difficult to make judgments as to your progress. At every stage of your development it is important to get as much feedback as possible. Only show your best work. Only then can you get a realistic measurement of your progress. The association with other artists and the resulting camaraderie can often be long-standing. There can often be valuable critical exchanges between artists. Don't hesitate to solicit their opinions. You can accept or reject any criticism, but you owe it to yourself to engage in such exchanges.

ARTISTIC SUCCESS

The only valid measure of your success as an artist is in the work itself. A number of artists have parlayed financial success and notoriety to where their acceptance by the art society is self-perpetuating. It seems odd that you rarely if ever see an objective critique of the art at this stage. Most attention is focused on the person of the artist, usually as a result of entrepreneurial hype or of pre-existing notoriety.

It can be fairly stated that the vast majority setting out to be artists have as their goal the creation of a number of pieces of work that will be critically acclaimed and have enduring acceptance. There are a vast number that would be happy to make a living with their art.

Since all artists are possessed with an ego, the praise and adulation from those who often know little if anything about art except what they like, or claim to like, can sabotage your progress. Also, their willingness to pay for your painting can easily mislead you as to the monetary value of your work.

Be careful to always assess the market so that you maintain reality in your price structure.

In the total picture, the truth of the matter is that the majority of buyers are not serious collectors. Most people buy a painting because the subject appeals to them. As your skills become more advanced, your prices should gradually increase and you will attract serious collectors.

As you improve, you can raise your prices but it is difficult and unwise to lower them. Financial rewards, even as a secondary goal can soon obscure your primary objective. Guard your image and price structure by not presenting everything to the market. Your reputation is established by exhibiting your best work.

FAILURE AND REJECTION

Once artists achieve a moderate level of proficiency with the technical skills, particularly drawing, they should not be reluctant to attempt any subject as a challenge. If your initial drawing is good it provides a solid foundation for completion of your painting. Work on your basic skills until you can be comfortable completing each step in the painting process.

Remember, much can be learned from failure so don't hesitate to step out and test yourself. It is safe to

say that all but the most accomplished artists have more failures than successes. To gain from this experience you must always be conscious of the advantage of being self-critical.

There are several factors other than technique that will affect the quality of the work. A lack of sufficient knowledge of the subject prevents a logical and truthful image, negating the possibility of success. Don't begin a painting without proper preparation for all of the challenges in front of you.

Another roadblock to a successful painting is the failure to start with a sound composition that expresses the artist's original emotional intent. Failure to make judicious use of line, mass, color and values may lead to unnecessary challenges.

All this accentuates the need for good and thorough preparation. Again, painting is about the mental process as much as the physical techniques utilized.

Throughout your career, proper attention to failure is one of the principle challenges that will lead you to those discoveries that are a part of the great joy of painting.

Be sure you address your failures directly and not move on to another challenge or they will be repeated and the problem compounded. Not learning from your mistakes is perhaps the greatest failure.

Don't worry about rejection. All artists, even the best of them, have experienced it. Find out what it is that certain people don't like about your painting. Failure and rejection are not the same. If either reaction is due to some aspect of the work itself, you should want to know about it and learn from it. When you exhibit your paintings, *you* already like them or they would not be on the wall. A good exercise is to stand behind the viewers and listen to their comments. Pay particular attention to the negatively critical remarks. Whether you agree with their opinions or not, much can be learned from another's perspectives.

The rejection of your paintings by a gallery does not necessarily mean they don't like your work. The gallery may have a full stable of artists at the time or several whose work is similar to yours. Ask for an honest evaluation and ask if they would like you to submit a portfolio for future consideration.

Both failure and rejection are among the most direct avenues to knowledge and improvement.

GREATNESS

Masterpieces and greatness are nearly always only determined by future comparison with your contemporaries and most often long after you are gone. The same is also true of normal *artistic* (not financial) accomplishment, which is the most the majority of artists will achieve.

Current fame and financial success are sometimes the result of fad and trends created by sales driven promotion rather than the diligent promoting of the true quality of the work. Such success is usually temporary and can often paralyze further artistic strides. This becomes a career hazard for an artist whose success is the result of hype.

If you do what you do as an artist with the pursuit of fame as a priority, it can well be a shallow victory, if you do happen to achieve it. Life is too short just to be famous for the wrong reasons. The real rewards awaiting you in your art are in the act of painting.

The majority of great achievers, philosophers, inventors, poets and fine artists have rarely been rich and famous or have sought out fame or recognition as their main source of inspiration. Their focus has usually been on the pursuit of excellence in their particular field of interest above all else. To pursue such interests halfway and let the commitment be influenced by an easy solution solely for ego satisfaction or financial reward puts the person in a totally different category. Devotion of one's life to the sciences or art as an individual passion requires making sacrifices, diligence and focus.

THE ART ELITE

By a very large margin, the number of artists painting today are working in the traditional realist category and most likely live in more traditional lifestyles. This is reflected in the overall economics of the art market. In essence, top money in commercial sales and auction prices is often dominated by work in the modernist genre. But, the overall economy generated by the sheer number of traditional pieces sold at all levels of price, greatly exceeds that of sales in the modernist field. This

causes some confusion and unreal comparison between the two quite different stylistic genres.

However, more importantly it is strong evidence of the natural preference of the population for traditional values and a natural association with the beauty of nature. This fuels our desire as traditionalists to represent that beauty.

The perception of an "Art Elite" in regards to the highly visible contemporary modernist market is the natural result of cultural design changes and should not be in any way in comparison with the advocates of traditional realism. Like comparing apples and oranges.

SKILLS & TECHNIQUES

A lways use the best materials you can afford. Good quality paints, brushes, mediums and painting surfaces make your job of learning easier. Brushwork is an important factor in creating a rich vibrant surface and one that is often overlook by many artists. Learn to use the various types and styles of brushes. Practice the different types of strokes. Learn to turn your brush to use the flat, the edge, or a light or heavy stroke to get a variety of effects.

Your brushes are the single most important tool you have with exception of your eyes and mind. LEARN TO USE THEM!

Study original paintings and discover what artists have done in terms of brushwork. You can see the effects

of light and heavy pressure, directional strokes, of using the edge or full surface of the brush.

Discover the difference between using thick and thin applications of paint. Know where and why to use them. The application of heavy brushstrokes of paint catches the light and are often used for emphasis in the foreground or on the subject.. They help create the illusion, which is what painting is all about. If you use photos for reference in your work, be aware that brushstrokes are often not visible in the finished image.

Work with a lush brush when emphasis is needed in your painting. After sketching the composition, blocking in the major shapes with values and color harmonies, begin to paint. Be careful not to paint over thick expressive strokes of paint. Think ahead about color and direction of your brushstrokes. They are important and become part of how your painting reads. When light strikes a textured surface, highlights are created. These highlights become focal points, especially when used with appropriate color and provide interest and spontaneity when skillfully done with purpose. Don't just put paint on the canvas with your brush—make it sing! The skillful use

of texture tends to enrich a painting even though it my not be apparent from a few feet way. It catches the light while flat surface does not. Beware; it can be overdone. It is especially useful in emphasizing the focal points or center of interest.

Learn to use texture. Load up your brush with paint and lay it on with one brushstroke. Two strokes can destroy the effect of the first.

COMPOSITION

Composition can be simple or complex depending on the subject and message to be communicated. A bunch of objects nonessential to your goal just makes it that much more unattainable.

The best option is to keep things simple. Focus on what you are trying to express subjectively. By concentrating on the essentials of composition, the challenges met and the resulting discoveries create lasting lessons. Leaving nothing in the painting that does not serve a purpose is a good axiom.

Never make changes either minor or significant in form or color without careful consideration. Again, it is

important that you keep your mind active every step of the way.

The practice of economy of form is generally an aid for maximum expression in your medium.

Intuitive changes are usually positive, but they too must be challenged before being made. Remember, logic and truth must be evident in the changes before you make them, for they are what carry your message.

Composition is perhaps most essential in first considering your painting. The most evident rules such as perspective and spacing of form are first considerations, after which the most subtle and difficult additions can turn a ho-hum painting into a more complete and successful work.

The concept of perspective is relatively simple. However, the means of establishing it in your paintings can involve a number of different important elements. You should be cognizant of them and use these elements as important parts of the perspective in your painting.

The elements of perspective can include all or some of the following:

1. Linear arrangements (obvious and suggested)
2. Color (Intensity, values, harmony)
3. Basic patterns of forms (including abstract shape patterns providing chiaroscuro to the composition.)

Composition emphasizes and supports the subject of your painting.

Compose your paintings with thought to abstract patterns and shapes important to your goal. The arrangement of all the above are what define the abstract quality of your paintings. Attention to color, values, space as well as defined and suggested lines, together are what accomplish that.

Much of good composition is subtle and often not perceived by the casual observer, yet, serves an important purpose for the composition. The artist must be aware of the subtleties and consciously make them a part of the work.

The object is to direct the eyes of the viewer and influence the perception of what they see.

ABSTRACTION

There are some concepts of composition very often missed by most of today's traditional realist painters. One is the concept of form represented by not only objects but also by color, value, line and shadow. Each of these can represent form in an abstract sense that may unify the composition of the entire painting. It is in the arrangement of masses represented by form and shapes achieved by the use of the above elements that constitute the abstraction in your paintings.

The abstract quality they can add to your painting is not often apparent to the viewer and can be difficult and easily overlooked by the artist due to its very nature.

The overall imagery of form that the abstract quality adds distinguishes a good painting from an ordinary one. The abstract arrangement of form represented by the above-mentioned elements, leads us to and emphasizes the principle subject of the painting.

The delicate balance between the two is a challenge that must be addressed initially when the composition is established but is usually enhanced throughout the process.

The inclusion of an abstract element in your composition is important to the overall success of most paintings unless the composition is a very simple one. It is what unifies the design factor of the painting without which focus on your subject may have a tendency to become lost.

An abstract design can be achieved with light and shadow by creating shapes that emphasize the principle subject. It does not have to be complicated, just thoughtfully done. Then it will be fascinating as a work of art.

Be conscious of the use of "invisible" linear directions and don't move forms for the sake of an abstract pattern.

A good painting is constructed of line and mass. These define and become the strong compositional element in developing a painting. They constitute to a considerable degree the chiaroscuro factor that directs the eye through the painting.

The important lines in a painting or drawing are not necessarily those that are complete in the sense of a beginning and an end. They can be suggested lines between

shapes and forms that lead the viewer throughout the composition.

Arrangement of mass in the composition can be suggested by value changes, such as shadows as well as solid forms.

The importance of mass is in the arrangement of light and dark forming the abstract quality that underlies most good compositions.

For the student, it is helpful to cultivate the habit of forcing everything they see into its simplest geometric form. This promotes the ability to think in terms of mass, which becomes an instinctive act with practice.

THE SKETCH

There is great value in the use of a sketch at various times during the process of painting. The first sketch is often made at the time of inspiration. These can be done quickly either in the field, in the studio or wherever the notion strikes you.

The secret is to be prepared by having a small pad with you at all times—just enough for a few notes and

small sketch. These are valuable aids to your memory as to what inspired you.

The second type of sketch is done prior to starting to paint and is simply color and value keys for your referral. As you become more accomplished, you may want make these directly on your painting surface.

With either they are not only important reminders of your inspiration and goal, but can save valuable time once you start to work. Taking a little of what leisure time you have during your day or during some pre-planned time can be very productive for some purposeful sketching. Such moments, set aside for that purpose can prove to be a great aid to developing both observation and memory skills.

Some artists like to make complete or nearly complete paintings out of their original sketches supposedly as a confidence builder for the eventual painting. In truth, it more often than not takes some of the freshness away from the eventual work.

It is common truth that a student must learn to draw. An artist should always draw throughout their career, whether accomplished or not. It is often taught to draw

with your brush. Few are skilled enough to do that without an underlying sketch as a guide. If you can do it, it helps to keep your painting fresh.

You neither learn how to paint nor why you paint until you suffer through years of frustration and sacrifice.

Often in life, youthful passion may eventually turn to true love. Similarly in painting, enthusiastic beginnings turn to artistic success only when practiced and understood.

THEORY

The arts should be above the conflict that exists between the Traditional Realists School and the Modernists. The former, based on historically proven tenets and the very broadly defined Modern schools are serving separate needs. Much of the latter is produced in response to the modern cultures need for decorative works compatible with today's culture and influenced by the "open to interpretation" ideal.

The traditionalists fulfill a need to renew and retain man's relationship with and awareness of the importance of the natural world as well as assuring the appreciation of the history of the arts. Inroads are evident in the other arts as well.

There are a great many modern versions of classical operas, plays and music that forsake the originals. Many

of these interpretations are well done, but it seems new works never seen or heard before would be preferred. Can you imagine the visual arts quagmire if artists were intent on redoing the classic paintings?

The modernist painter's intent is to create emotional response to their work and the entrepreneurs use it to stimulate perceived meaning in the images produced. This is analogous to the familiar "Rorschach" tests. Such challenges can be easily produced as there are no established rules or standards.

No one confuses the written classical music with improvised jazz. So should it be with the visual arts. One approach to providing visual pleasure should not be disparaged or praised at the expense of the other.

Many buyers and collectors of contemporary modern paintings can be awakened to the meaningful aspects of realism. This is especially important if they have never seriously contemplated its universal concepts, its inherent truths compared to the "open to interpretation" mystery, not to mention the overwhelming entrepreneurial opportunities to satisfy a large egocentric market for modern work.

The concept of truth in painting may be difficult to comprehend and for a painter to adhere to. What the traditional artists strive to represent in their work can be more easily understood (by themselves and others) if they adopt a disciplined logic in every aspect of their labors.

There is absolute logic and therefore truth throughout all things natural. There is logic in how and where trees grow, in how water flows, in the effects of time of day, of color, temperature, the elements such as wind and rain, in fact in all things natural. There is no logic and therefore no truth in a sunny day without shadows.

The key is to think during every step of your painting and think logically about all you have learned.

THE SENSE OF BEAUTY

Beauty is in ordinary places. The vision of the artist is in the ability to see and be able to show the world something it generally, only subconsciously, thinks about. Subconscious thought counts. Traditional realism is the artist's personal commentary on nature.

Emotion always precedes analysis. That is true when the viewer is attracted to a painting. This is an important fact for the artist to remember. It alone is enough reason for a student to study and learn the time-tested techniques and skills needed to paint with conviction.

Since an individual's aesthetic sense of what is beautiful is dependent upon one's life experiences, including what he is taught or is influenced through reading, does it not follow that as life experience narrows and becomes limited by focus on or away from certain subject areas that the perception of beauty is either dramatically changed or lost?

Today's modern culture and the adjustments of educational institutions that followed have made our traditional concepts and to some degree, our awareness of natural beauty an endangered experience. Think about what the average person's lifestyle is like. The norm includes time spent watching television, movies and a myriad of recreational activities. Travel has never been easier, much of it to urban cities or resorts. The list is endless.

How many people today under the age of sixty have ever had a garden? Or taken more than a casual look at a flower, river, trees, etc? Further, how many have ever had a desire to own an original piece of art or, for that matter, even one of today's fine giclée prints.

I am sure you get my message. Traditional realism is faced with a huge and important promotional problem. We must restore the respect and admiration for the natural world and representational art.

PERCEPTIONS ABOUT ART

There is a logical analogy between the failure of the populace in general to think on a spiritual or philosophical level about Traditional Realism and Modernism in regard to painting. "Pretty" or "Ugly" seems to suffice as a description for the masses. People seem generally comfortable living in today's synthetic/plastic environment.

The cultural changes that began following the Industrial Revolution overwhelmed traditional concepts that reflect our core origins and spiritual connection to the natural world. From a practical viewpoint it has been a matter of supply and demand. One of the consequences

is that there have not been enough institutions teaching traditional theory and technique.

As a result there developed the modernist schools in keeping with the culture changes. It has become a case of "oil and water." There is undeniable value to each and they must co-exist without fighting over what is art.

Traditional Realism is constant in what it represents while the Modern school changes with the perceived demands of culture and the resultant industrial design trends.

Both serve a common need but the similarity ends with the term "spiritual communication".

CAPTURING TRUTH

There is absolute truth in nature. The beauty and solitude observed in nature expresses spirituality in every artist's interpretation of it, whether consciously or not. That spirituality in varying degrees contributes and underlies the beauty in what you paint and likely parallels your own life experiences and thus has meaning.

Mountains born of violent volcanic eruptions, canyons formed by wind and flood, skies in cloudy stormy mood are all undeniable truths.

As artists, our own life experiences include turmoil, disruptions, conflicts and challenges after which there is usually some sense of tranquility and appreciation of challenges met through the lessons learned at whatever level you are in the process.

As an artist, you will become more accomplished and adept in the ability to capture the various means of expression in your work. It is those means of expression that become the soul and substance of the subjective elements of your painting. The materials of the trade are only the tools that are guided by the soul of the artist.

Don't work blindly. Observe the world around you. It will help your painting and enrich your life. An artist must think logically about everything he paints or the results will not ring true.

You must have sunlight in your heart if you expect it to flow from your brush in a convincing manner. You must observe, appreciate and remember what you see. Analyze what you see in terms of the shapes and the sug-

gested linear arrangements of them (objects or edges that direct the eye to another).

There are occasional exaggerations or exceptions but they must be done purposely only to enhance the truth. They serve the purpose of emphasizing the larger more important truth. They communicate the spirit of your work to the viewer. Example: green sky is not truth, but the logic and truth of color perception prevails.

There is truth also in visual perception of form and depth as pertains to drawing perspective. The representational artist must understand those concepts. As an artist, realize and appreciate that there is in painting, an inherent truth and significant meaning beyond the successful execution of the technical skills.

These are of absolute importance in establishing a sound painting. If these elements are not apparent, then move things around, change their scale, value or color to achieve them. Don't let an idyllic scene escape you because of some big ugly or poorly placed tree or rock, move, change it or leave it out. Take a little time to consider the compositional alternatives and make decisions before you have to make corrections. Decide what it

is you want to say and what within the scene is either important or unnecessary. This should be done in your preliminary sketch.

It is often said that artists see the world differently. Share that joy with those around you. It will enhance their life and yours, and give them a greater appreciation of the beauty of nature. They will understand your obsession with it as an artist. Understanding how artists look at the world and what they see around them should be an important aspect of any collector's assessment of the artists work.

SUGGESTIVE TRUTHS

Don't just paint the physical truths of what you see in nature. Use your technical skills to express the emotional truths (the suggestive elements). Paint for the mind not just for the eyes.

Search your emotions and use nature's gifts to provide descriptive elements to guide the way. Take heed of the poets and writers communication of images with words alone. Keep it simple.

What an opportunity we as artists have! It takes great discipline to think poetically as you paint. As you paint the suggestive (subjective) elements such as sunlight, shadow, rain, etc. in your composition, think of what you are visualizing in descriptive terms. The translation may help in your selection of colors, values and add to the creative impact of your painting as well as to your pleasure.

Does man have the capacity to live in this age of modern technological wonders and maintain the spiritual connection with the natural world, from where all real miracles occur and from whence all man-made creations spring? Are we up to that connection? The awareness of the origins from which we came seems to be disappearing through the skylight of technology.

Realism in the fine arts is one of few windows open to those fortunate enough to have access. It must be taught, practiced and it must be a significant part of our culture. Above all it must convey the element of truth.

What are rarely seen in our self-made synthetic culture are those things natural. The miracle of regeneration of all things natural has given away to images of

Challenges and Discoveries

space ships and unnatural beings with misshapen heads, speaking weird tones.

Are we fostering belief that these are truths? Not even close!

ROMANTICISM

The romance of fine art has several distinct realities. First of all and most important is the romance the artists have with their own chosen endeavors. This is the most immediately passionate reality of all. Without it there would not be any art.

Secondarily, there is the enduring love affair collectors often have with the artist's paintings. This passionate relationship between collector and art is often an intense and life-long pursuit.

Throughout history, the romanticized perception of the life of the artist endures. These often vastly embellished scenarios have been the chosen subjects of countless works of literature and film.

The very nature of the artist's creative process is one of a solitary endeavor, which puts increased demands upon living a normal life.

153

Third, there are many casual observers who are "Art Lovers" but can neither afford to buy art but do appreciate beauty when they see it in the arts. Appreciate this audience as well as those more directly involved in the art world.

SUMMARY

◆━━ ⊏◈⊐ ━━◆

After thinking carefully over what I have written, there are several points worthy of repeating. I'll risk repetition for the sake of their importance.

First, use your time wisely and form good work habits. Time spent in planning, study and experimenting is never wasted time. Never start unless you feel an excitement about it and be particularly attentive to your preparation and beginnings. Don't try to finish before you are ready. Accept the discipline of hard work.

Secondly, strive for simplicity. Subordinate what may hinder progress at several levels of development. Use others examples mainly for reference and inspiration. Don't include any elements in your painting that are not necessary to convey your message. Search out the essence, the subjective elements in your paintings.

Third, work from life. Go to nature for your subjects and inspiration. Find beauty in the common place. Ordinary things present all the problems there are and thus become extraordinary. It all just awaits your eyes to see and your mind to interpret.

Fourth, be yourself! Don't be a rubber stamp by trying to paint like someone else. There is a big difference between being influenced by someone's style and becoming a mirror image of it. Trust your instincts and do things the way you want to. You will enjoy the freedom and the art will take care of itself.

The mere fact that you decided to paint and continue to do so sets you apart. None of us believe we can ever paint a masterpiece. However, if you continue and are serious about your painting, you will have great rewards in a number of ways. It will be a liberating experience that will be exclusively yours. It will provide you with a personal closeness to nature that you will learn to enjoy greatly. It will open up a whole new world of interests and friends.

Again, study. Be self-critical. Work consciously for improvement and you will have a grand time.

The life of an artist equates to all natural cycles in that a seed is sown, nourished, allowed to grow and with luck eventually bloom. This ultimate glory goes virtually unnoticed but by very few. Nature's inherent beauty remains relatively unknown today except to the occasional visitors and observers who make the time and effort to partake of it in the natural world. They also can experience the appreciation of that connection in your work.

For those of us who appreciate and try to capture nature's bounty in our work, we are seeking to share that healing quality that we experience with the viewers of our finished art.

Painting captures the mind. You become absorbed in the creative process whether successful in your efforts or not. Perhaps it's that inner drive to represent the creative beauty in the work of the greatest artist of them all.

To successfully do this we represent color and values to achieve to some degree an energy that communicates. If you don't feel that in what you are doing, if you aren't energized by it, then you're wasting your time. The lack of that energy is a root cause for that "starving artist syn-

drome". Without proper preparation and discipline you may also hunger emotionally.

The artistic or technical quality of your effort is not what your painting is about. Any real effort is a part of the painter himself. If your goal is financial, you are painting for your ego. Paint for your inner satisfaction instead.

When you solely equate sales with artistic success and turn over your work to entrepreneurs just looking to profit you may as well be a plumber. Find a representative who truly appreciates your work.

In placing your work for showing, it is unfair to all concerned to offer any but your best efforts. To do less can be detrimental to the artist's image and damage your price consistency.

Many have tried to make an objective analysis of what it takes to achieve success as a fine artist. First, of course, one must decide what is your own particular measure of success.

Observation of the market over a period of time shows that a degree of commercial success can be achieved with a careful and tenacious image develop-

ment program. This extends beyond the mere steady production of work and includes personal, professional and business relationships. It is well established that if galleries and collectors like the individual artist as well as their art that the relationship generally works out fine.

However, you must make a conscious effort to develop such a positive image with all your associations.

I hope the preceding few pages have provided some enlightenment into the joys of painting and particularly in the importance of good preparation and constant study. Some aspire to become professional fine artists. Others seek an activity that will provide a joyful escape from the trials and tribulations of daily life.

Read this little treatise again and realize the pleasure awaiting you may be in the process as well as in the final artistic achievement. You will encounter many challenges and make many enlightening discoveries.

Also for yourself and for those who may see both your work and your contentment, realize that as a traditional realist painter you are presenting a much-needed awareness of the natural world.

Painting is a complete relief from bothersome daily distractions. Every scene you paint has limitless possibilities to provide the artist with a mesmerizing sense of freedom and discovery, to fill empty hours with mental exercise and creative expression transforming these vibrant moments of solitude into a work of art that exposes our shared humanity.

The challenges and discoveries you enjoy on your path as a painter totally absorb the mind.

I hope all that can be yours!

ABOUT THE AUTHOR

A fter earning degrees from the University of Southern California and California State University at Los Angeles, a highly respected and distinguished career in law enforcement and as founding partner of a national consulting firm, at age 47, Vic Riesau turned to the arts.

He has been a successful artist and sculptor for over thirty years. Vic's artistic inspiration comes naturally as he was raised in the foothills of Southern California and later spent many summers packing into the High Sierras frequented by many of the early California painters such as Edgar Payne, Jack Wilkerson Smith and others. His parents lived for years in Cambria on the Central Coast, an area he frequently paints.

A prolific sculptor as well as a painter, his works range from monumental commissions such as "The Hand of God..." for Point Loma University and "With a Courageous Heart" for the San Bernardino Civic Center to limited editions for collectors.

At the 100th Annual Exhibition of the California Art Club he was honored with the Award for Excellence in Sculpture from *Fine Art Connoisseur Magazine.* "In the Line of Duty" a 12'x14' bronze memorial stands at the Capitol in Sacramento. Vic works can be found in the permanent collections of the California Immigrant Museum in Truckee, the Carnegie Museum in Oxnard as well as in the collection of the Autry Museum of Western Heritage in Los Angeles. He was also honored with the Patrons Choice Award at the Autry for an 8'x6' bronze, "The Bronc Buster."

Vic has returned to the easel with passion. His paintings contain striking compositions and the pictorial challenges met prompt emotional reactions from the viewers at exhibitions in some of the finest galleries nationwide.

Riesau's art has also been exhibited at The Pasadena Museum of California Art, The San Bernardino County

Museum, The Frederick R. Meisman Museum and many other prestigious venues.

Vic Riesau is a Signature Member as both a painter and sculptor of the California Art Club and serves on its Board of Directors. He was also a founding artist of the Masters of the American West Exhibition at the Autry National Center.